CAR MA

is a book about

Cars
Art
Romance
Music
Attraction

Carnage
Asphalt
Rage
Madness
Allies

dedicated to those I love
who give me hell

by ALISON MOSSHART

A **HELLS ANGLES** publication
First printed, 2019
All art, photography and writing
by **ALISON MOSSHART**
unless otherwise credited.
FIRST EDITION

www.alisonmosshart.com

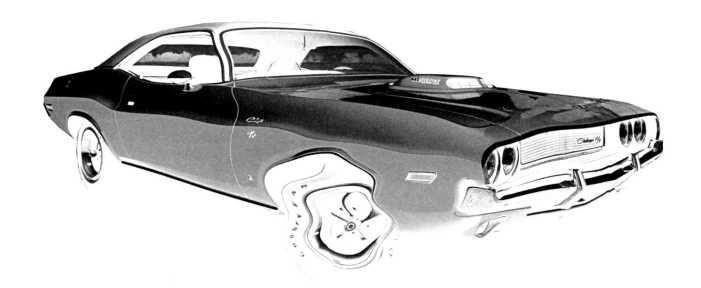

For more information:
Third Man Books, LLC,
623 7th Ave S,
Nashville, Tennessee 37203
A CIP record is on file with the Library of Congress
FIRST USA EDITION

For more about the book:
http://thirdmanbooks.com/carma
password: carma
ISBN: 978-1-7333501-2-9
Design by Alison Mosshart
Layout by Jordan Williams

TALK TALK TALK

Every move we make is a conversation. Tornado sirens going off. Every move is a talk. A fight. A beat. You put all your love and anger there. Into every brush stroke, word, chord, every look into the camera and hook you tap out. That pencil scratch, digging into the paper. Taking down a phone number. Hiking up your blood pressure. Tugging at your shirt. All those letters you write, too fucked up to send, exist, out there in the streets. Eyes of the universe. The cops speeding past. Counted 6 in a row. You wanna hit the accelerator. Got a song your head. Feels brutal, but honest. Obsessive, sure. Amoral, perhaps. But you can see into the future and out there in the distance, value doubles where passion lived.

Every move, a conversation. That's what I said. Nothing is thrown away. We just keep working. Bringing 'em closer or backin' 'em up. Whatever we want and whatever we don't. Trying each other on. Everyone. We're all doing it all of the time. Successfully or not. Gigantic or privately. Out looking for heaven with no idea of what it is or where it's been, just guessing, jerking around. Let's party. Yeah, all of us. A life's work. Bombing down the road with the volume up in the darkness, our volatility driving us toward the foolish, fatal, interesting- love. We just want to lose control and hang there, live where beautiful things take gasoline. Beautiful things that take your breath away cos they're dying and surviving simultaneous-

Like we are. Talkin'. Under low hanging stars we can lick, get personal with. Under spells we'll happily pay for. Blowing it all just to drive what's driving by. To be in love. Make the connection, get the vision. To be here. To have been. To be sick with it, shook down by it, burned alive by it. See the light at the end of the tunnel. What's florescent. Beautiful. Hard. Sure. And here we are. All of us. We are what we make and what we make of this.

We are the engine and the wheel and the axle and the fuel and the jamming into gear and the spin-out and the straight line and the zig zag and the back-end and the inside and the broke down and the high shine. Born to lose and win and wind, like smoke rising on any indiscriminate afternoon. Thru endless stretches of black night. We speed. You can smell tomorrow on our breath. You can taste impatience on our skin. You can see the death charge in our eyes. 700 horses, panting, jumping. - You wanna hit the accelerator? Hit it. You got a song in your head? Let it fucking rip.

- Alison Mosshart, February 2019

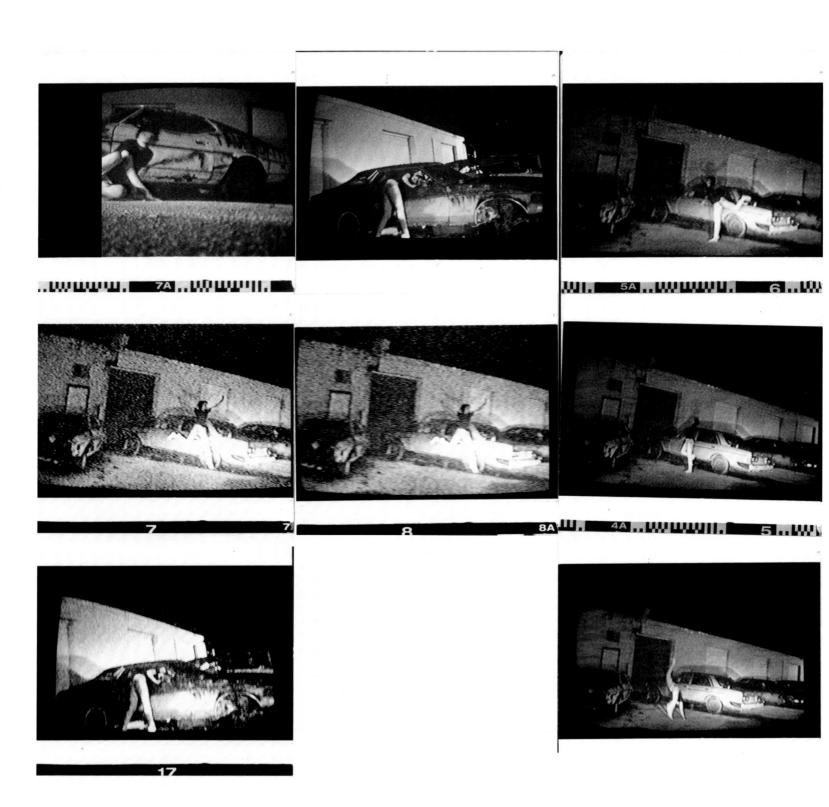

4

AM

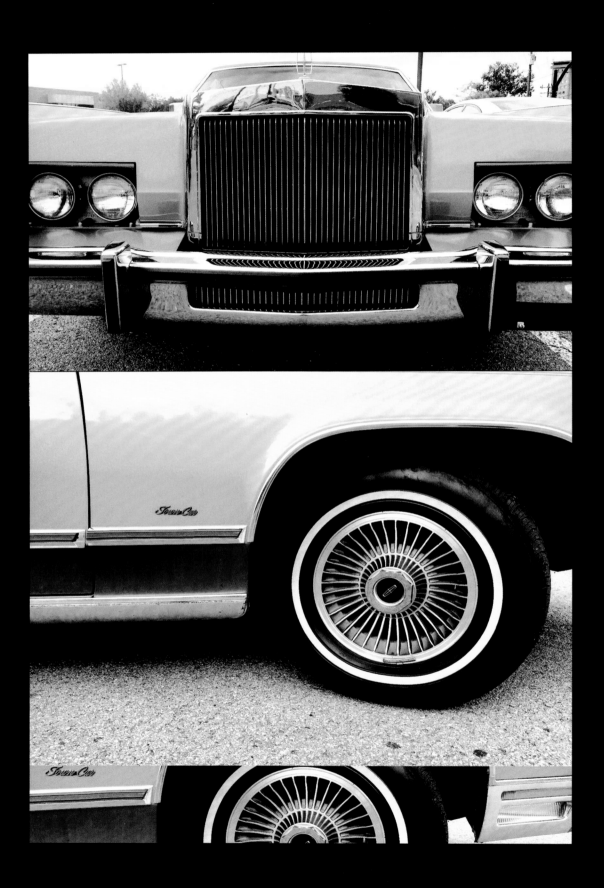

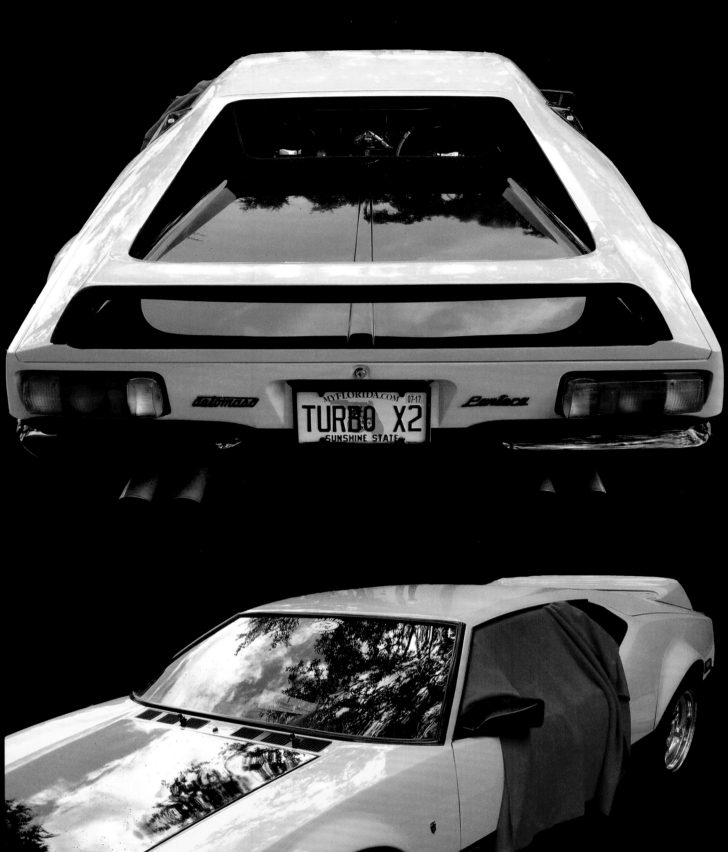
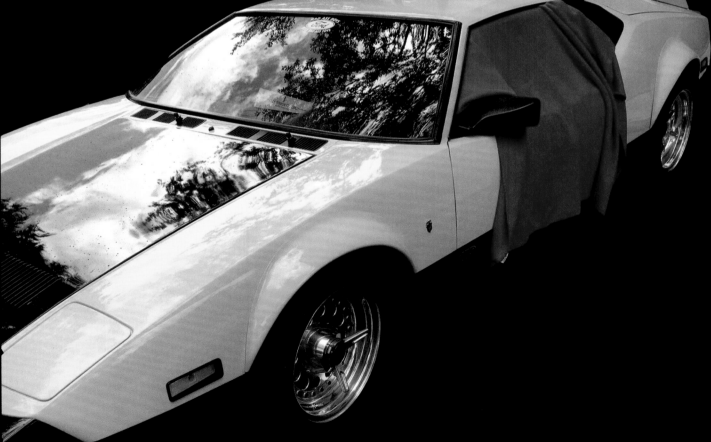

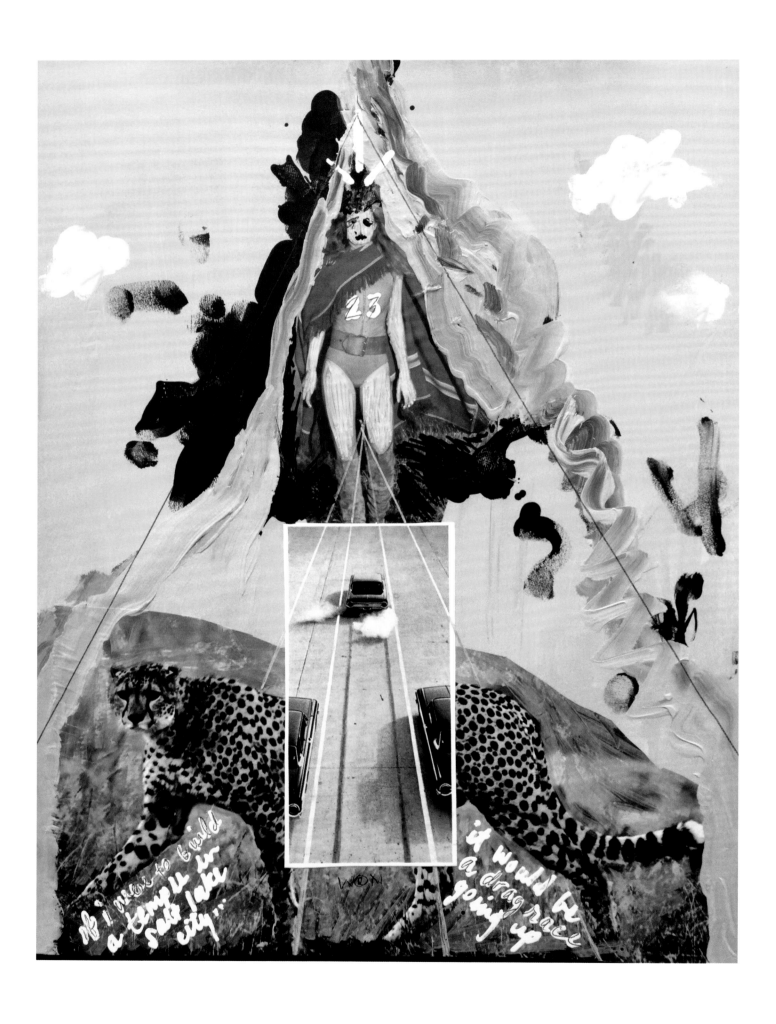

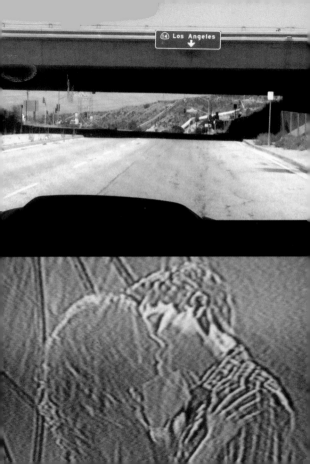

WINDOWS UP

Boy always smoked with the windows up before giving it up. Always made it so it was a bubble, his world, thus our world, *the* world, a bubble full a smoke, rushing down the highway

like the highway *was his*.
And the engine, *he built*.
And the oil, *he pulled* from the earth himself

We were passengers in this, in it to win it, in this bubble paid for in cash, often bullish with his foot. Under that black alligator boot. Suns rose and fell. Lands flew by. And nothing was permanent because permanence wasn't important, nor was it fast enough.

PINK WHIP

Even the soul who parks that pink whip in the YMCA parking lot has a YMCA membership and works it, wants to feel the burn, wants a

hot body

under that great suit, behind those dark sunglasses, down here in Nashville where the city slick of the North mixes with the sassy kink of the South. Like slow spun cotton candy is both hard and soft. All sweaty and sticky as he drives her home.

LAST PACK OF HOLY SMOKES

I was down in Lakeland Florida for a few days. An army of women were in the street outside my hotel waving banners, "WOMEN FOR TRUMP!", right after Trump had just professed to grabbing strangers pussies. So there I was

walking around Lakeland's historic district holding my pussy

in the cannibal sun and feeling betrayed by these women and furious about Trump, while noticing the streets were full of *insane* cars. Insane cars and these guys in their flip-flops and Florida gear slurping Pepsis dressed like toddlers loafing around polishing hoods and mirrors and cranking down windows. While the wives and the girlfriends, with under bites like bulldogs, swung their banners, slurred their slogans, burped their sodas - kept following me around cos I was

walking right thru the car show still holding my pussy

thinking to myself, probably out loud, I had better photograph these cars, since I'm here. Somehow save these cars' souls, if I can. The last of chrome innocence. The last pack of holy spirits in the glove box. Take 'em and run and go lock yourself in your room and

let go of your junk

triple bolt your door, close the curtains, light one up… see into future. If Trump is elected, all these folks who support him

will probably get screwed six ways from Sunday. Crying holy smokes! When all these pretty cars have to go to auction. Lakeland, FL 2016

SALT LAKE CITY DRAG

Got my ear to the ground and I'm always looking over my shoulder, for I am never sure in Salt Lake City

what is street legal

Been plenty of times but never longer than 15 hours and that's only about enough time to cut up a copy of the New York Times from the hotel lobby and turn a ping pong table backstage into an art studio, play a gig, take a shower, make an exit.

LA

I have mixed feelings about you. I love you. 'Love' like the way someone falls for someone they've never met. Obsessed pathetic eager clueless easy love. You amuse me and suntan me against my will through my windshield. I think about you a lot with one eyebrow up. A city of movies.

You look like the movies

Your light is toxically cool. I've never been in the movies. Maybe one day I'll be in the movies and understand you and we'll become close- kiss on camera close- close in that kinda' ego-tastic dry sarcastic funny not funny brush fire kind of way I hear so many people say they love LA.

PARIS TV

I don't know how you got those American muscle cars for me through the narrow streets of Paris into the TV studio. I asked for them, but I was half kidding. I desired them but I never thought in a million years. And suddenly we're on stage and there's

2 American muscle cars on stage.

On my left- an old black Mustang. And to my right- something even more vicious- with us in Paris on a set without doors big enough to drive them in. TV magic. I'm so happy about this that I have burning sensations of love in my heart, kid wonder; it's like I'm floating. Around in a country that still dreams. And the crowd gets crazier and crazier the higher I get. Camera people spinning around us and the cars, guitars and the cars. Paris a city that runs entirely on the excesses of heart and passion, desire, makes true- the imagination. Beasts. Paris, where beauty can live forever and be worshipped openly, and shall be. And if you're dreaming, you are in fact a native, kissed on both cheeks extra. And plied sideways with wine.

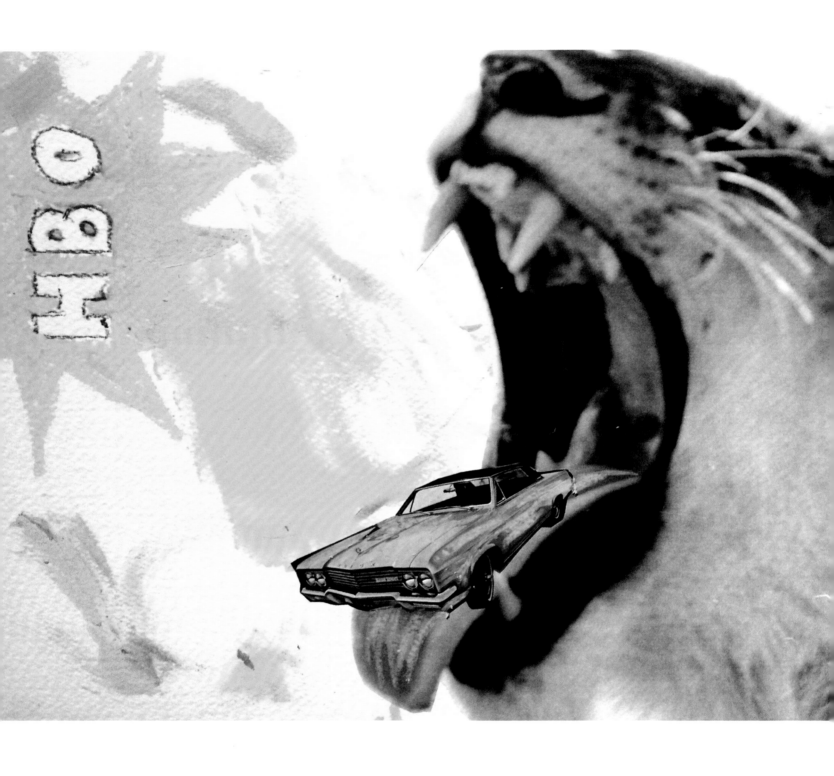

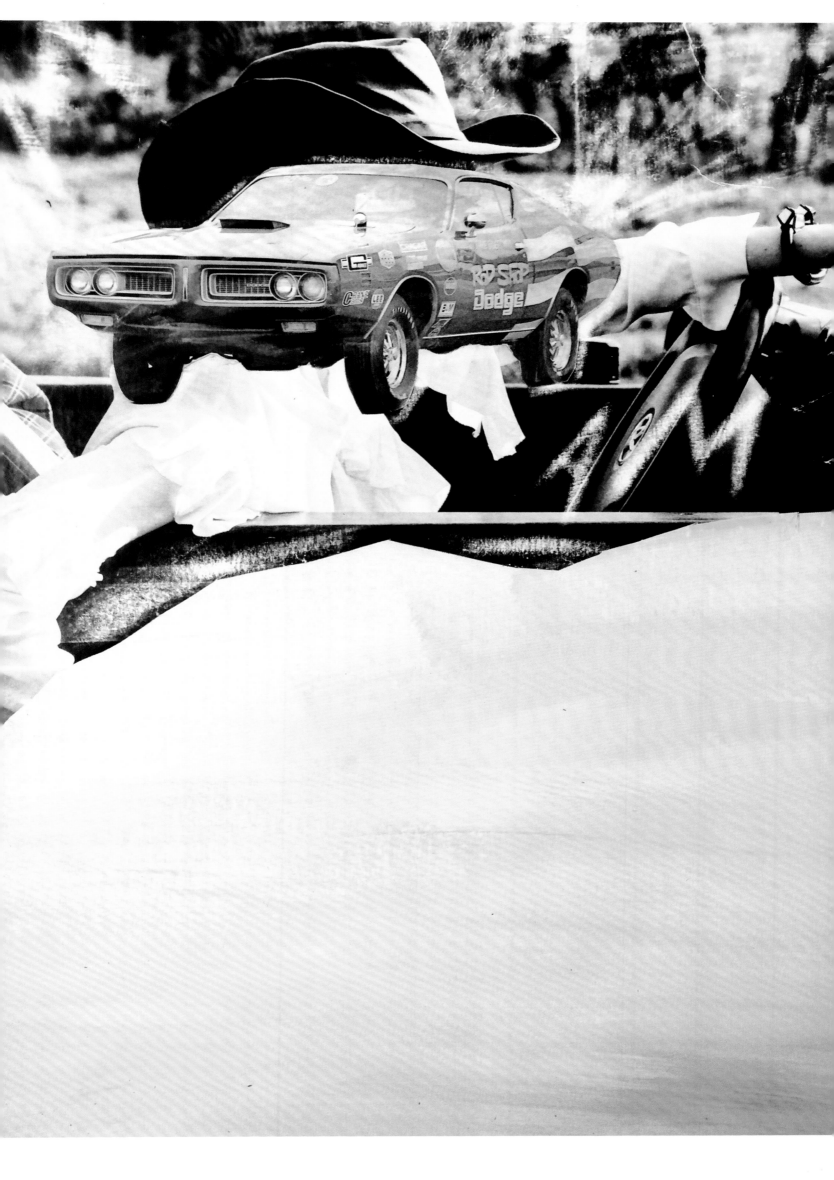

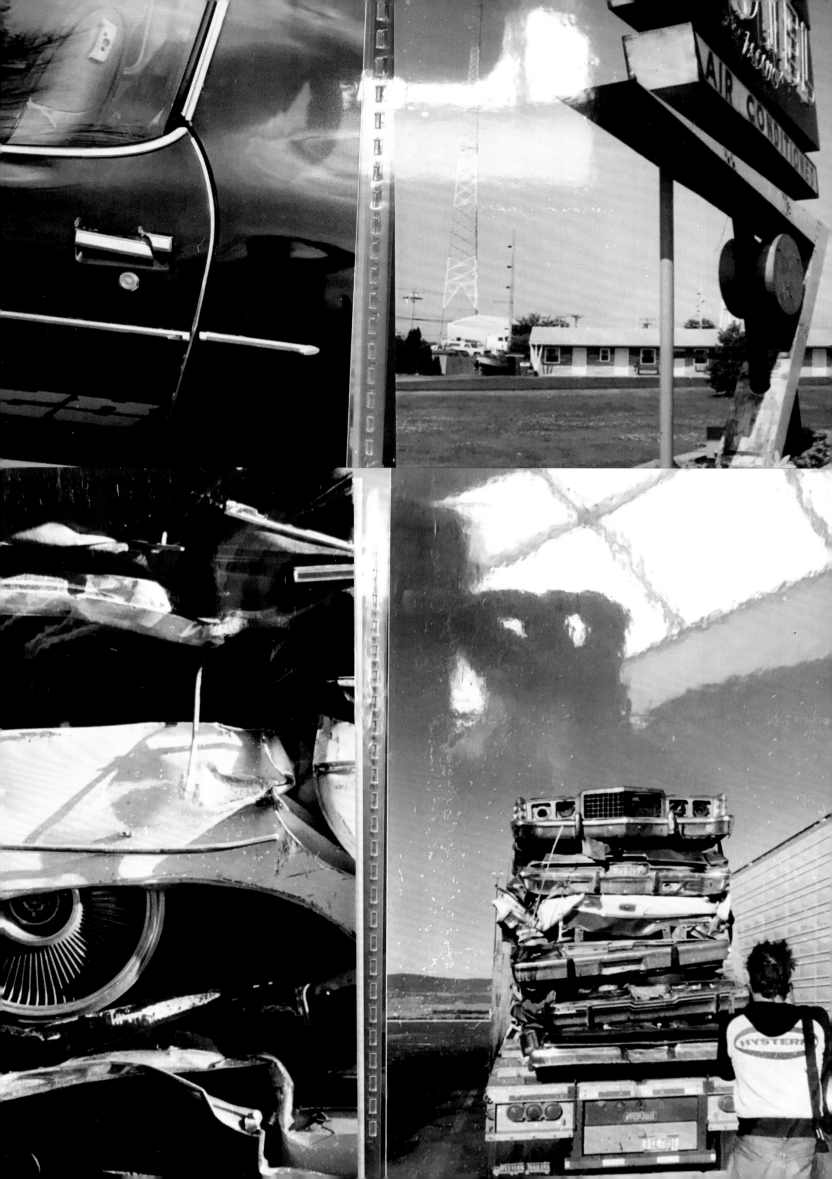

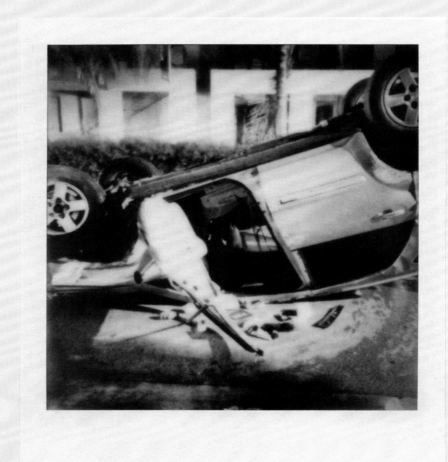

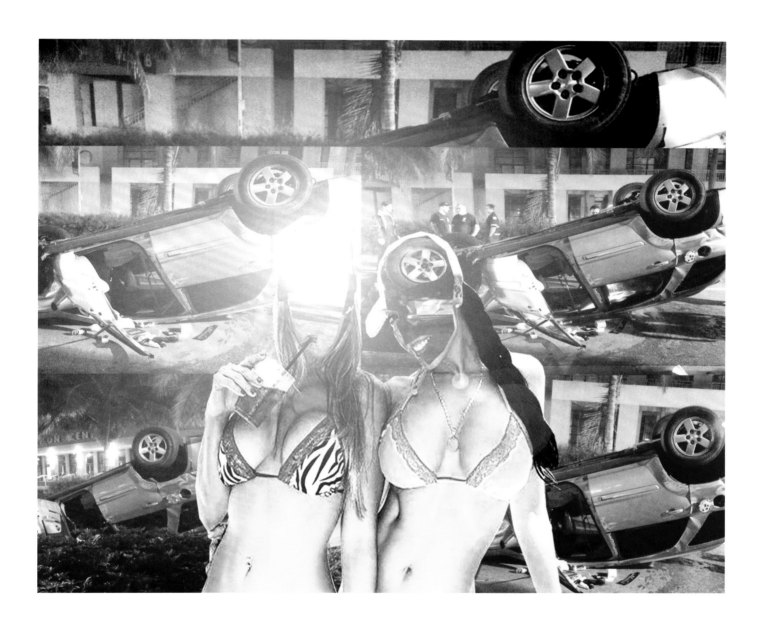

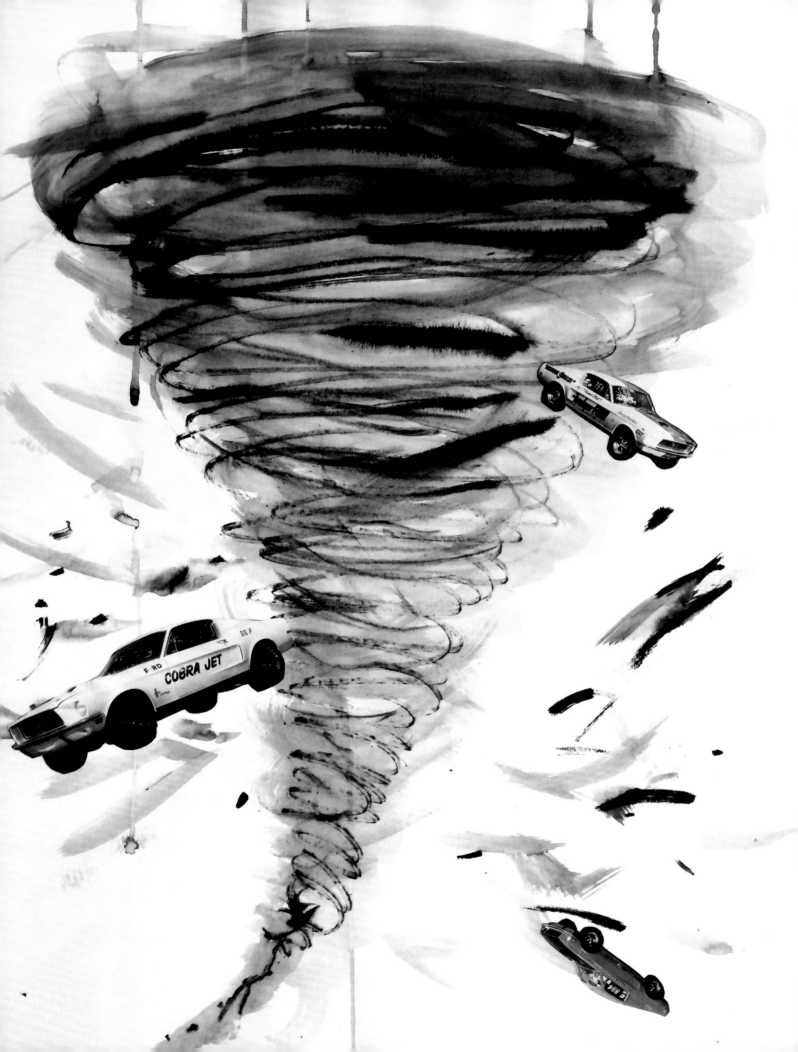

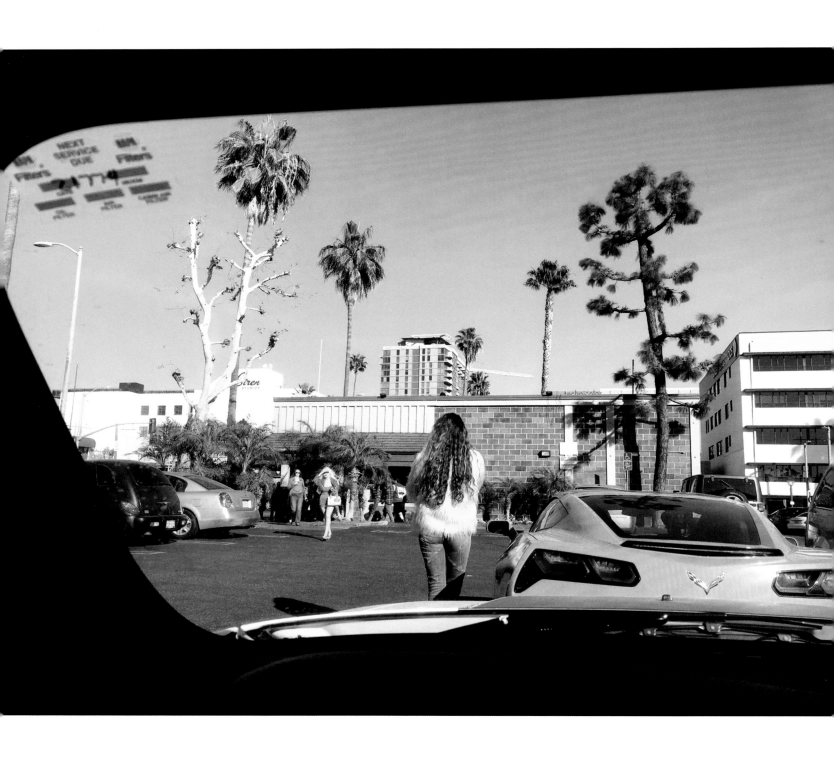

CABLES GALORE

It's lineage. Heritage. Respect. Looking at guitar cables on stage, is to me, like looking at David Hockney's swimming pools. Tire tracks in the road. The veins in a body. A spider's web. Highways from an airplane.

America's thread

Tread. A tumble weed up close. A patch of road where so many have come to burn out and impress and fuck in backseats. It's a visual biopsy biology batshitolgy of who we are.

THE DISTANCE

The distance that I went for you wasn't out of charity. It wasn't to save you. It wasn't to change you. I did it because I'm selfish and excessive, and built for it, the hard ride, the good time, butterflies in the stomach, being so sleepless it gets

stranger

and stranger

I like it.

For instance. You know that brief unexplainable moment… when you realize you are lost, deep in the wilderness, can't hear the road, no light in the distance… The moment that comes right before you panic and start losing your shit, when all of a sudden- you just LAUGH? A raucous lunatic laughter…comin' from the depths of god knows where, completely defiant, this chemical reaction sending you the wrong direction, and yet

You love it?

The *high* before the impending doom is how I would describe what I felt like with you. Every minute of it. I dug it. The distance I'd go for you was endless. For this new real of truer truth and painless pain and blackest black. You had me stuck at the top of a rollercoaster high as fucking Jesus. I knew I was fucked from the very beginning but…

Who isn't?

I didn't care. And who wouldn't laugh in the face of danger to know that kind of love? It doesn't come around often. Maybe never. But if it does, you get in your car and drive a hundred and five, crossing state lines one after the other and you stop for nothing. You don't even blink. You just go the distance.

SONIC STATES OF AMERICA

Seeing America through your eyes was like seeing America for the first time. Everything looked loaded and wide open. New colors were being invented 24/7.

America was funnier and weirder than I had remembered. Beautiful. Kooky. The Statue of Liberty stood on every corner. In between the bailbonds and the beauty parlor. Liberty's mistress hung out in parking lots and sipped from brown paper bags. Her torches ablaze. Off the balconies of cheap motels. Out the windows of dark apartments. Her gowns sweeping. Through the candy isles. Over the rooftops. In the audience. Toes dangling over the Grand Canyon.

Everything felt possible.

Every morning a sonic boom.

Everything was fresh and new and we, the free outlaws, were running invincable through the country. Lost, chased, pulled over, constantly. Laughing, out of money, happy, hungry, cutting across corn fields like razor blades, blowing through towns like the rolling stones before anyone'd ever heard of the Rolling Stones.

We had that kind of naïve ego and seemingly endless luck, youth, beauty, perfect health to gamble with. To see

like that. To feel no pain. Charm. America. Guitar amps in our laps. That car we destroyed, those tires we melted on the hot asphalt, the speeding tickets, coughing up the cash we paid the cops, always down to the last dollar, getting by on fumes. America.

Where we gonna sleep tonight? Who we gonna meet tonight? Could *tonight* be *the night*?

The guitar we smashed and buried in the desert, still out there somewhere in the sand.

MIAMI

What the hell. I'm looking around and I can't for the life of me figure out how you flipped upside-down and lost your marbles all over the pavement in the middle of this thoroughfare that's lit like

candy and jello shots and bikini tops

with nothing obvious to hit here. But you did it. Sure nuff you really flipped out. *Girl* like you meant it. It's certain, rolling you over ain't gonna make you whole again. So just be a wreck. You're such a wreck. Be the wreckiest wreck. No one can fault ya for being this honest so late at night.

ADMIT IT

¿Por qué me revelas todo?

¿Por qué vas por ahí cantando esa canción?

¿Por qué te ves guapo usando camisetas blancas y chaquetas vaquera azul?

¿Por qué hablas como James Dean, como si estuviera aquí?

¿Por qué me miras así, si no quieres que te mire yo a ti?

ANGELYNE

Angelyne puts little cardboard boxes in hip shops around Hollywood. The cardboard box has her scantily clad hot pink picture on it. You write your name and phone number on a ticket and put your ticket in the cardboard box. Someone who knows Angelyne will call you and leave a message on your phone telling you that you've won a ride with Angelyne in her pink Corvette.

OH BLACK SHARK

I keep all the parts of you I screw up. Body parts that break down and get replaced then. I keep all your trash. Never will your bones know a scrapyard. Not on my watch. Tires that get worn and metal that gets mangled.

The screw that came loose from somewhere god knows where

I keep 'em for I respect your originality, literally, and you know it. I'm like Victor and you're My Creature. No part of you will ever be wasted. I'm always putting you back together again. Creating your twin. As I dust you and I polish you and humanize your guts, always telling you how handsome you are, what an angel, what a dude.

You are just so easy that if we had a kid it would
never cry. Just ~~your bandana down in louisiana and~~
~~baby i'll be there with a good n' pickled liver yet~~
~~we'll just live forever~~

just wavey
just wavey
just wave your bandana down in louisiana
and baby i'll be there good n' pickled liver yet
we'll just live forever i'll wait for you by
the river in the red and orange casino. you know i
don't gamble just like smoking in the air condition
and the 24hr lights on you

Louisiana S Town 2013

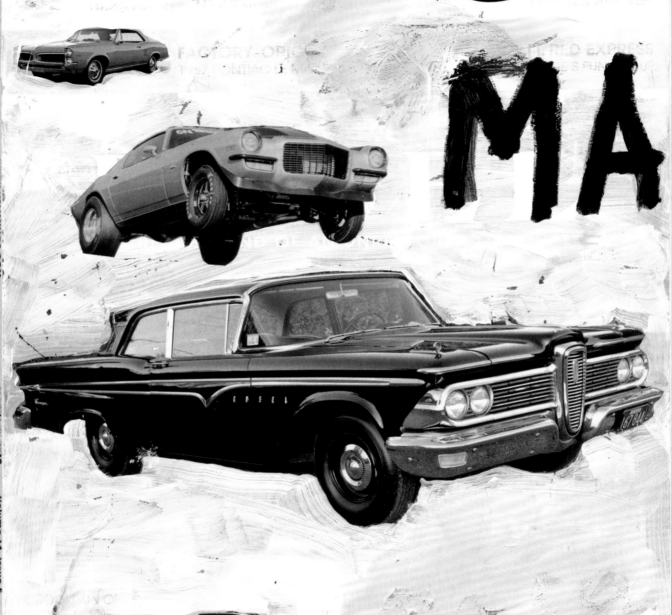

CAR

MA

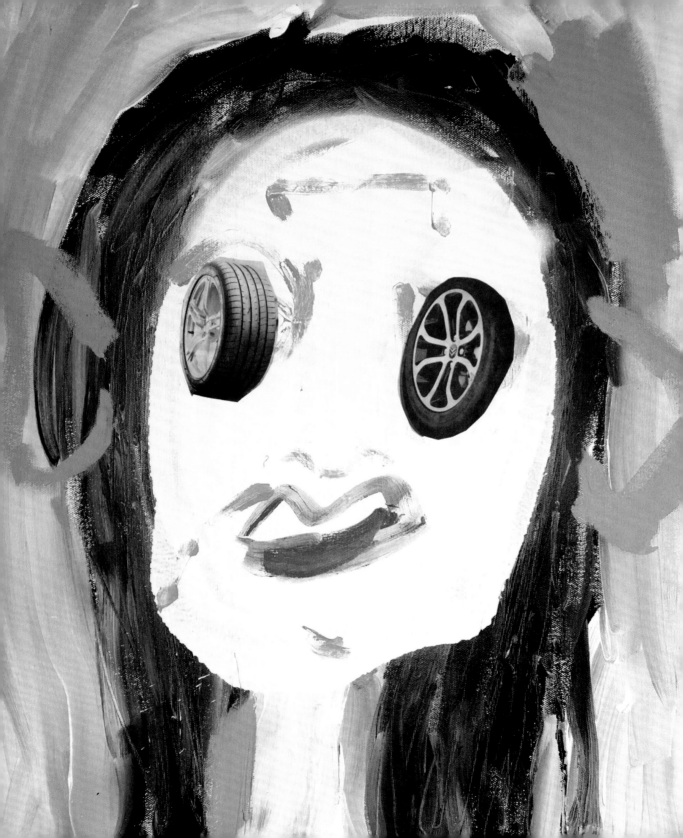

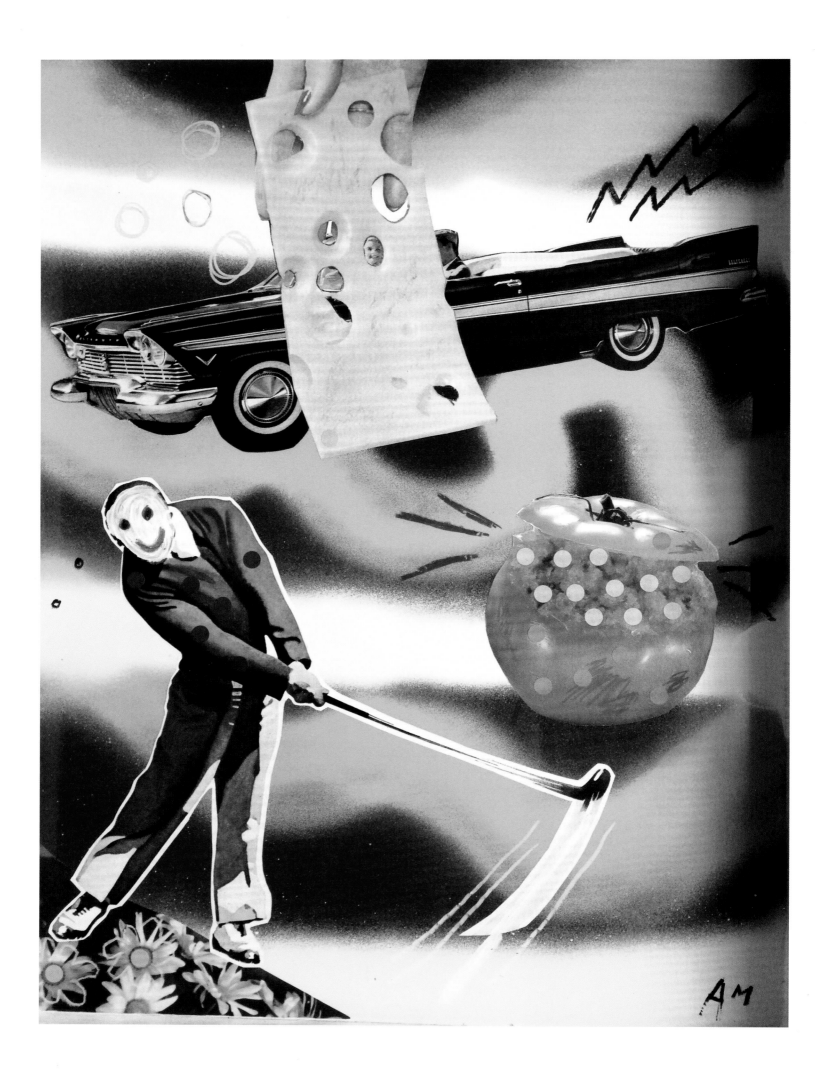

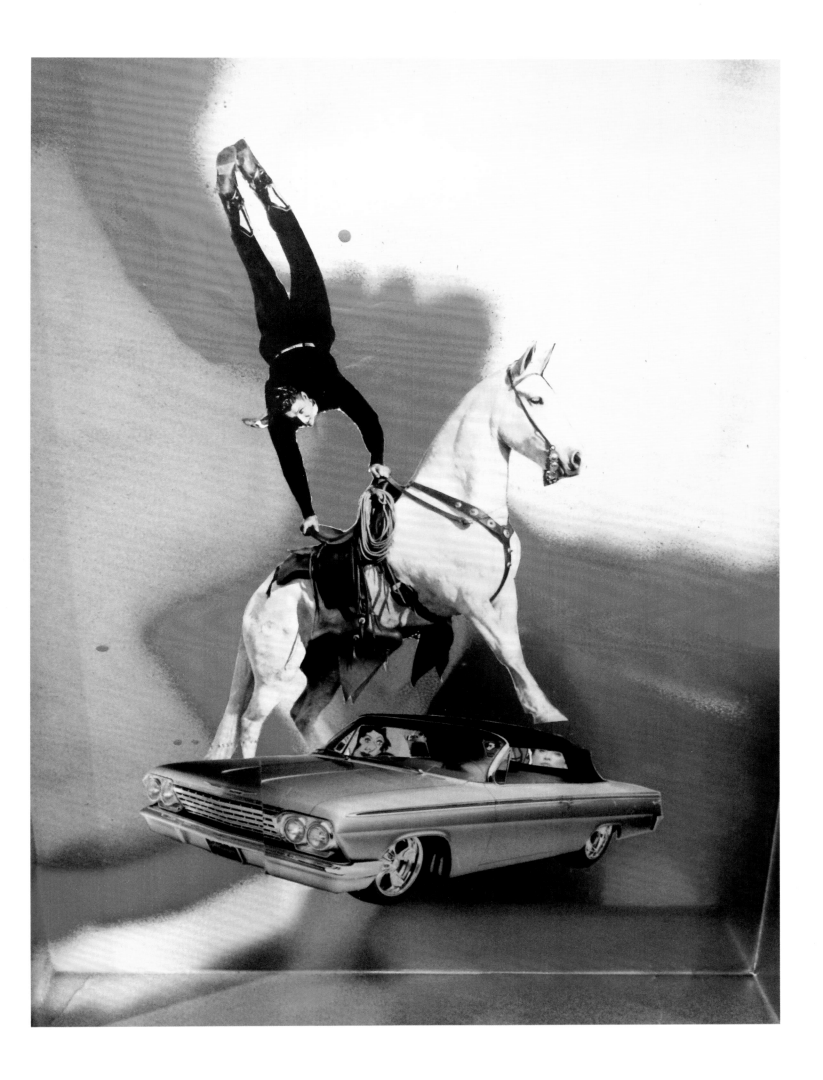

HOLD ON

You held on to the dashboard while I drove us down the freeway. You gripped tightly and laughed with your eyes real wide open, smiling out at the long road ahead of us like you saw the smoke lifting. Smoke I couldn't see. You told me- I wasn't like the other girls with the 6 shades of eye shadow, the hips or the tits … I was more like a chainsaw. Listening to Bad Brains. I could make you laugh. And you felt good. Riding in my car, a world all it's own, unlike the other worlds with the deaths and the downers and the troubles and the depressions. We should've never gotten out of the car.

LOUISIANA

The slow cruisers, cruising low riders drunk drivers talking to one another through their open windows, whole conversations, they go *that* slow. *Catching up wit ya*

The frozen booze drive-thrus make it easy for crackin open seafood

and killin' desolation blues over creaky hotel floors, hanging by the juke box full of benjamins, the bar, the slots, the tequila, it's open, it's all open til 4 or 5am. It's everything.

And in the hung-over crossed-eyed morning all the old cars parked up I see 'em, the black and chrome with cop wheels and primered doors and I see Him, and the feeling of bliss is in me and my headache is funny to me spilling my coffee smoking by the curb looking at the morning, looking at the future, already looking forward to the sun going down again, for I'll be in my element and so will you, your eyes so blue like medicine. Louisiana.

Where nothing and no one'd dare pull us over for slow cruising and late nighting and heart breaking low riding, never mind drunk driving. All the stars were shining. Louisiana. Roll your windows down.

AROUND AND AROUND AND AROUND

I'm just wondering if you'll ever do what he said to, the bad advice that was good advice, the hard thing that'd be easier to do if you were high or drunk or a punk. If you weren't - freakin' on the wrong stuff - breathing through a clean lung. If you could only trust the voice in your head that's turning you on, and stop being embarrassed, stop wondering where it ends and start thinking about how it is. What's tellin you to cross the river, down in one, follow the shadow, let go of the wheel, and just like honey. She'll give you what you really need. A big fat ticket out of here.

DEEP IN THE WOODS

When I get the invitation to go to the woods and be alone, a chance to drop out, I take it. A little cabin on an island wholly surrounded by nothing but green leaves and mist. It's a place where everything is supremely quiet, save for my own blowing and howling and mind tricks.

Before I go, I send a case of coffee, a case of wine, a case of paints and canvas, a typewriter, guitars and microphones. This tower of boxes awaits my arrival and makes it really hard to wedge myself through the door of the cabin. This tower is telling- I'm not really a woodsy desert island sort of person. I don't exactly know how to do it. I worry about not having enough to do and finding myself a little too face to face -with myself.

Once there, it immediately starts getting weird. *I* immediately start getting weird. It's as if I can see myself from outside the windows. A woman inside an all encompassing mirror. There's nowhere to hide. No whiff of distraction. No internet no phone no friends no prospects. I start to get loose. I start walking with a fake limp and talking in a different meter. I move the rug out of the way and try break dancing for the first time. Why not. I am anyone. I can be everyone. The looser I get, the more insularly outward, the more manic, the more I'm left laughing –

at my own jokes…

I'm the only fucker around for miles. So now I'm suddenly the funniest fucker I've ever met. And here we go

with the nonstop hits. Nonstop hits. Paint all over my face. Bang bang on the typewriter. Moving all the furniture, covering the room with artwork, lists of titles and fictional names, tape everywhere, floor covered in plastic, painting words on the firewood before I burn it, talking water into boiling… My inside voice becomes my outside voice and ever louder beyond thinking type thoughts. No longer afraid of nature or dying from wild animals. I am wilder. I am the mother fucking wildest.

Time stands virtually still. The clock doesn't seem to change. I can go many hours straight hyper focusd on one little teeny tiny itsty bitsy drop in the ocean before I notice…

My handwriting on the boxes and sense the beyond. What I wrote when I was back in the city. When I drove to the post office like a person in the world, in society, off the island, on the road, in a car, in clothes I put on incase anyone saw me. I look at the return address in bold capital letters. I look at it intensely. Yet I feel little affinity, nor do I miss it or who I used to be- 2 days ago.

I tell myself a joke- a joke that would never fly in the city- and I laugh so fucking hard I'm convinced I'm the funniest fucker I've ever met.

ELIMINATOR

X: Whatever I said on the phone last night, that's what I did. Remind me. I don't remember, I'm... It's like really late here.
Y: I remember. But I don't care. It's always the same.
X: Oh, well that helps. Hey hold on a sec… hold on
Yeah right there is fine- perfect thanks man. Where do I sign… oh yeah. Thanks a lot have a good night- Yeah,no- I'm good- No no this'll do it. I will. Ok. Have a good night.(DOOR SLAM)
Y: Who was that?
X: Food.
Y: You watched a band play after your set, I called and it was really loud. You weren't listening to me.
X: Oh that's right. ZZ Top. Last night. I spent two hours watching Billy Gibbons' legs.
Y: I told you I was leaving you. I was so mad at you.
X: You did? You were? (chewing) -You still?
Y: I guess not.
X: What's going on there?
Y: Nothing.

CHEMISTRY

I never knew what to do when we were in the same room because nothing about us being in the same universe made sense. I used to watch you breathing and think that's really something great you're doing, breathing, hey good job. But who the hell are you? I wondered what you were like back in the day when your door was open. When you were young and we were younger and you thought we were gonna be good friends and relate. Grow old together. You planned on it. That was the point right? What happened? What made yr radio silent?

You could have been a super hero of normal. That's heroic. Normal is full a' tragedy and stories and interest. Normal is glory. Great songs. But no. All your shit out on the table, where was it? We wanted lyrics. Cos it's just too weird to love somebody you don't even know like it's the law or something.

All that time. Suspicions and no real proof. Blood without chemistry. Record collections smashed up having something to do with religion. Skateboards offending the congregation. Couldn't take us anywhere cos we'd shaved our heads. Devil kids. Saints though.

Was it the music you hated? I found your guitar. I found it covered in dust in a closet. Was it the things you once loved that you couldn't bear watching us discover and fall in love with newly, despite you? Or was it love itself, ignoring you, sitting cross legged miles from you, smoking a cigarette in the shade, reading the paper with her back turned on you? Like bleach an' vinegar in an acid house all out of milk. The physics of rage. Red blood boiled at 85° under blue skies in the Sunshine State.

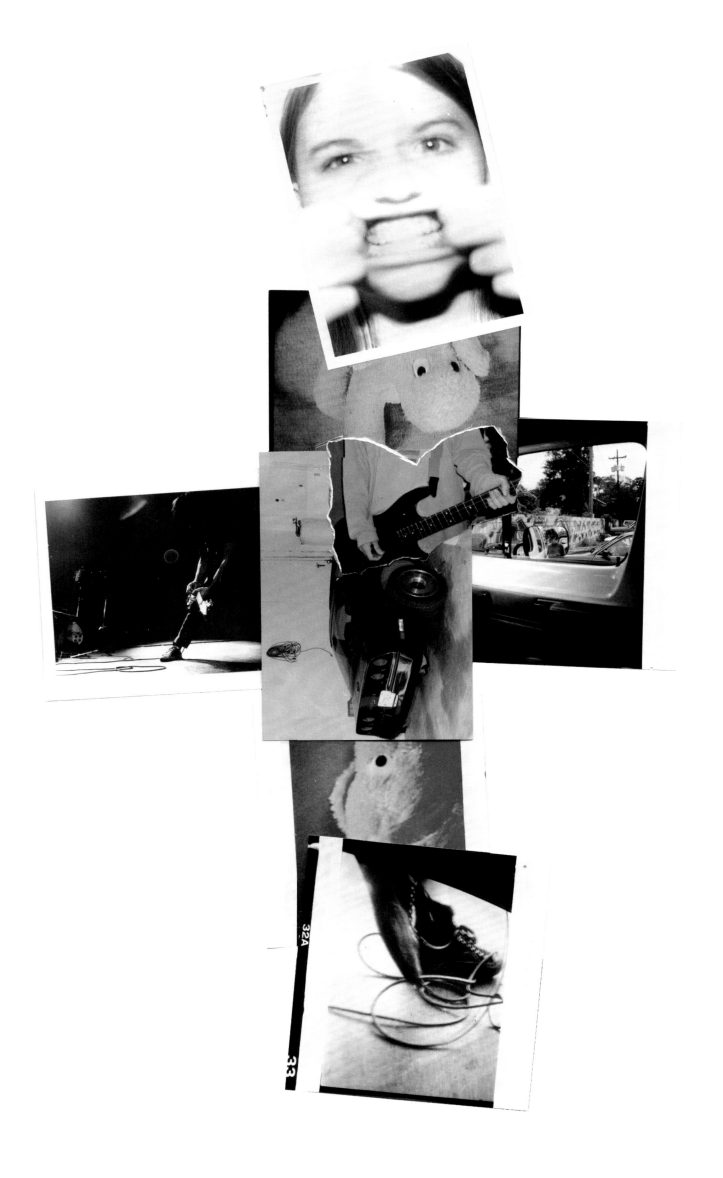

A BONE AND A CLU...

DEDUCTION.... SEDUCTION

DAUGHTER OF A
USED

NIGHT. SHIF
HEART OF A. DOG

PETER
FONDA

552
05
0876

CAR DEALE

SMOOTH PICTURE

PRESENTED BY

NIGHT PEOPLE

THE
END OF THE WORLDERS

38

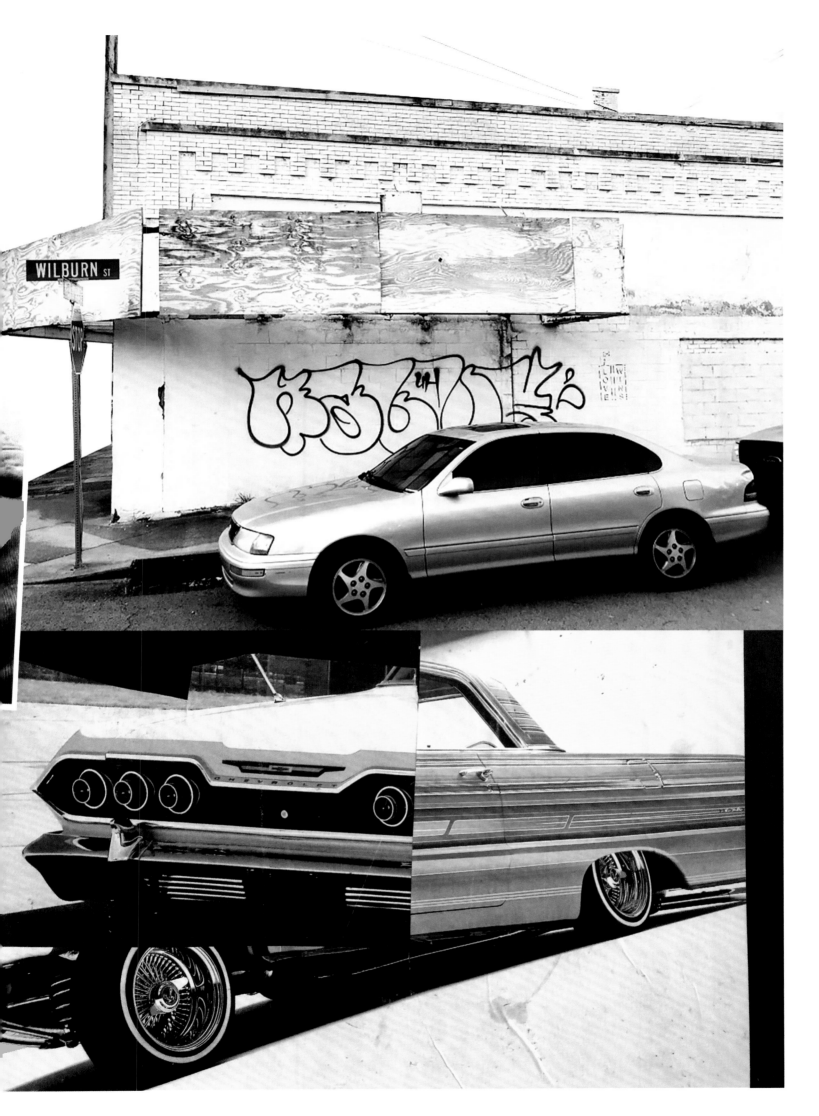

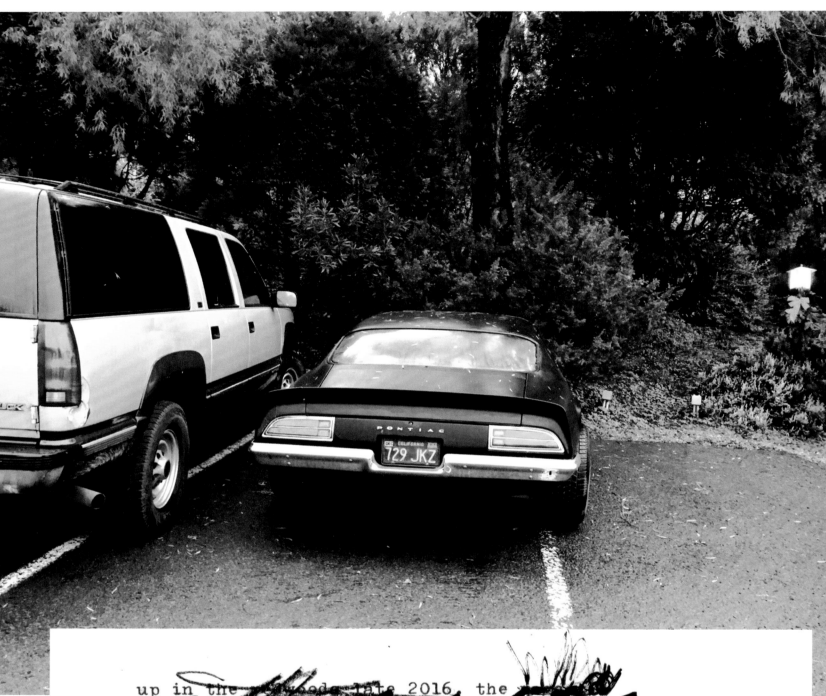

up in the ~~redwoods late 2016~~. the ~~~~
~~the majestic trees the wild ferns the towering~~
~~beasts and all i got was a photograph of the~~ ass
~~of a pontiac~~. ~~all hips~~ ass
~~wheels~~ ~~postcard~~ ~~somewhere~~
~~nothern cali~~

up in the redwoods late 2016. the
the majestic trees the wild ferns the towering
beasts and all i got was a photograph of the ass
of a pontiac. all hips and ass all hips and ass
~~wheels~~ wheels for days. postcard to myself from somewhere
nothern cali

LET'S START A BAND

12 years old and unrequited
13 so sexual
14 guns r' blazing
15 want it all
16 get wheels for cruisin'
17 got shit to prove n'
18 tattoos you think you'll
19 always love
20 playin' for money
21 throwin' dice
22 from peak to valley
on 23
from sea to shining
on 23
it's all or nothing
on 23

KEITH AND CHRISTINE WALK INTO A BAR *where Barry Newman and Richard Prince are waiting.*

It's late afternoon in a sweltering Mexican border town. The four sit together in the back corner of an empty bar. The bar is dark, lit only by a few neon beer signs, jukebox, bare bulb over register. A waitress is smoking, moving slow, looking at them suspiciously. Is that the actor? She can't quite tell if...

Christine never takes her sunglasses off. The box fan is blowing up a lot a' dust. The four are laughing, smacking the tabletop, lightheaded from the journey. They order mole the color of motor oil. Beer tomato tequila lime. She brings over the order and hears them discussing state troopers y fuel intake y back roads in some gas guzzler language neither English nor Spanish. She thinks they're talking evil cos she keeps hearing the one they're callin' Prince say, "Demon."

Keith's sucking on an ice cube, Barry's blowing smoke at the ceiling. They all just drove down from Los Angeles. Hadn't planned on it being a race. Just kinda happened that way. Riling each other up. 2 hours of breakneck driving, trying to be first to cross the border. Their muscle cars, hoods still hot, are all parked up in a line outside. Local kids, (you hear them giggling and yelling out of view) have surrounded the vehicles, are taking pictures on their teléfono celulares.

I'm dreamin'.

The Peterson Museum in Los Angeles is one of my favorite places. The low rider exhibit full of incredible Latino sculpture that drives and cranks all ways. Political, familial, cultural icons. Art. And the Keith Haring cars. Make me cross my heart and hope to die. That exceptional white 1963 Buick Special he painted all over with orange and blue. The yellow 1962 SCAF Mortarini Ferrari 330 P2 Childs Car covered head to toe in his big black marker stroke. And the red 1990 BMW Z1 which is a funny little thing, toy-ish, looks great vandalized. The cars that were movie stars are here too. My favorite is Christine, the 1958 Plymouth Fury with it's blacked out everything.

She's radical.

But I wish they had the Vanishing Point 1970 white Dodge Challenger R/T. I always look for it even though I know it's not there. In its absence, I can't help but fall into the same reoccurring dream as I walk through the building. That one day on the second floor it'll be up on a platform, a Challenger I painted all over, with murdered out windows like Christine-

a true modern lover

but old school like Haring, erected from the wreckage of Vanishing Point, reconstructed with respect to the hands of the master, Richard Prince, - and Barry Newman will drive it, deliver it

from one side of the country to the other

in less than 24 hours- wreaking havoc the whole way. And we'll all be able to hear it. It'll all be broadcast on a soul radio station and Bobby Doyle will be singing:

"The girl done got it together…"

SHE'S A TRIP

We rented the most awful car. An ugly tan gold Toyota something with tan fabric interior from Alamo or Alcatraz. The thing didn't go faster than 80 and it ate gas like a dirtbag and took corners like a grandma and it's wheels we're like baby wheels. It's front end was a disgruntled frown of bad design and lameness. It hated itself. But there we were driving this piece of shit up the coast taking all the back roads to see what there was to see, stopping at freezing beaches to look at the ocean and pulling into all the national parks to see the giant redwoods in the rain. We ate at empty restaurants and drank too much wine and slept in hotels that were unpopular and vacant. We got rained on endlessly. We were always soaking wet. We drove with the windows down smoking, the rain just pouring in, but we got used to it cos you get used to it. Finally we get to Santa Rosa and I say we abandon this pile of shit car, send it off, and we end up on foot going from one side of Santa Rosa to the other side of Santa Rosa and ate some ceviche and drank some booze along the way, and when it was time to fly home we were walking across the tarmac to get on the plane and Stacy said something really funny and I was laughing, really belly laughing hard and suddenly a bunch of vomit flew out of my mouth and landed on the tarmac. It was very surprising to both of us. Very surprising. Ejecting from nowhere. Blasting puke like I was exorcising a demon and my god, 3 days it took. 3 solid days with my head in a toilet back in LA ridding my soul of that Toyota.

ROAD KILL

…is like little Persian rugs. Little bear skin throws. Little swaths of natural fabric. Little tears of mohair sweater. Little samples of cotton polyester. Little cuts of living room carpet. Little trims of indoor outdoor. Little clown wigs on the ground. Little peach fuzz on the chin. Little slices of smoke stained beard. Little threads of human weave. Little mohawks on the freeway. Little crew-cuts in the right lane. Little pigtails off the exit. Little French braids at the stop light. Dyed pillarbox red.

BOOK OF LIES: FACT # 1

There's just one knowin' you need to know, if you ever dream of being in a band that shacks up on a tour bus. Listen here. It ain't that kind of toilet. You can't shit on the bus. Don't do it. The tour will be over. You'll be disowned, run over, shot at. Your band will fire you. The driver will oil spot you. You'll be homeless and hitchhiking. And fail. This is how lives are ruined. This is how civilization ends.

ANIMALS

If we lived like animals, it didn't feel like that then. No one pointed it out, that I can remember. It didn't seem that bad. No one said it to our faces. We were sleeping on floors. We were hanging out of windows. I remember outrunning tornados and drinking from the fountain. I remember truckers in the basement and eating straight out of the garbage. Dressing up at the gas station. People coming over. People came over all the time. Playing gigs right in the living room. Cranking up the neighborhood. Doors were always open. Staying up all night and sleeping until evening. We were all just living. None of it was evil. There was nothing remotely wrong with people. Living like animals.

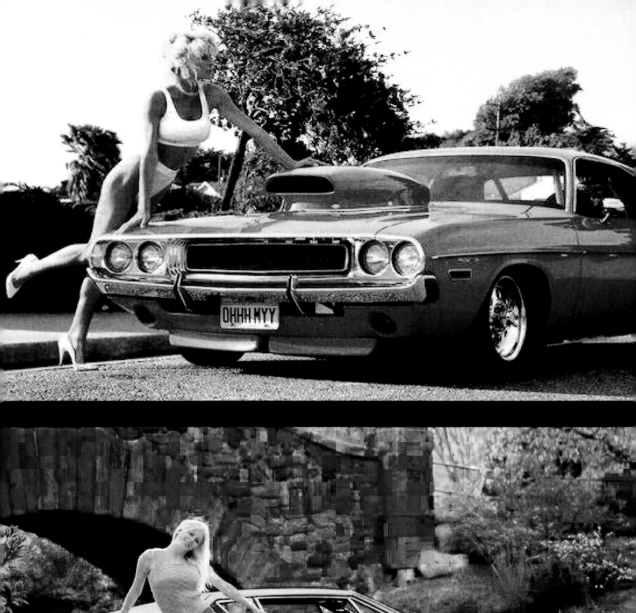
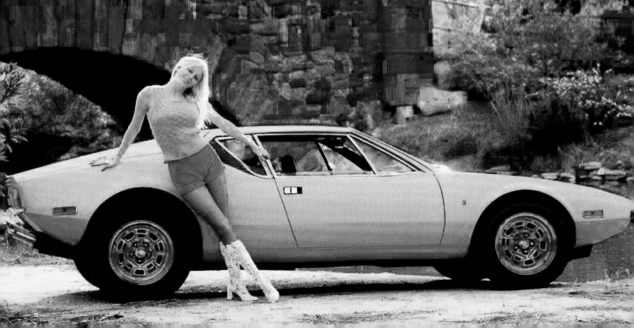

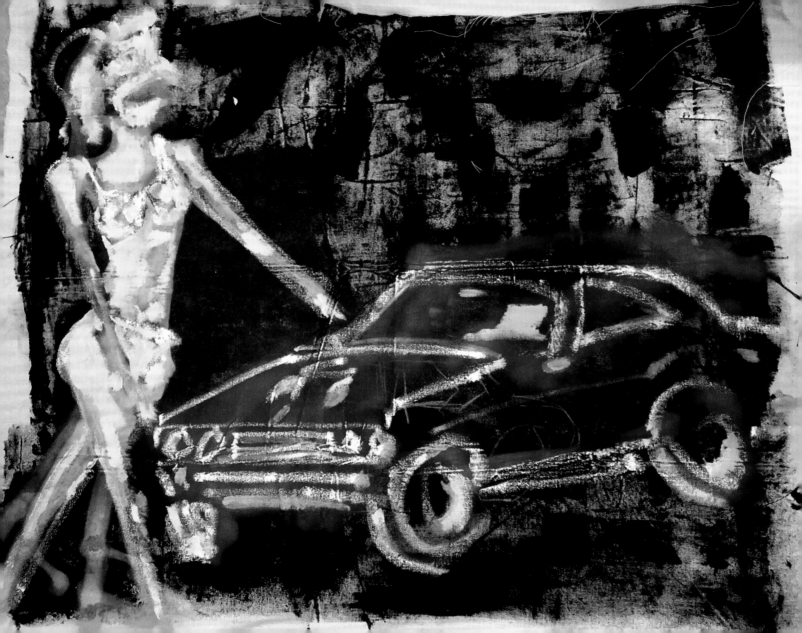

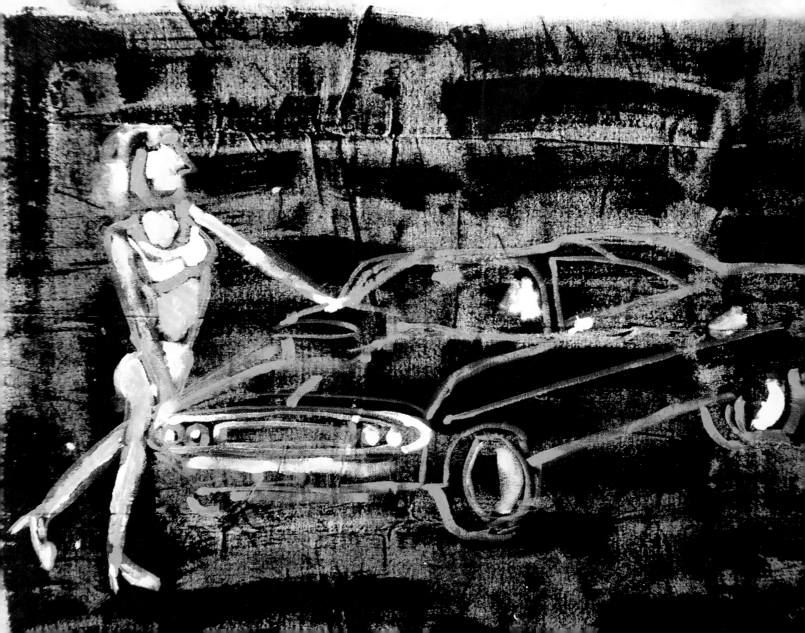

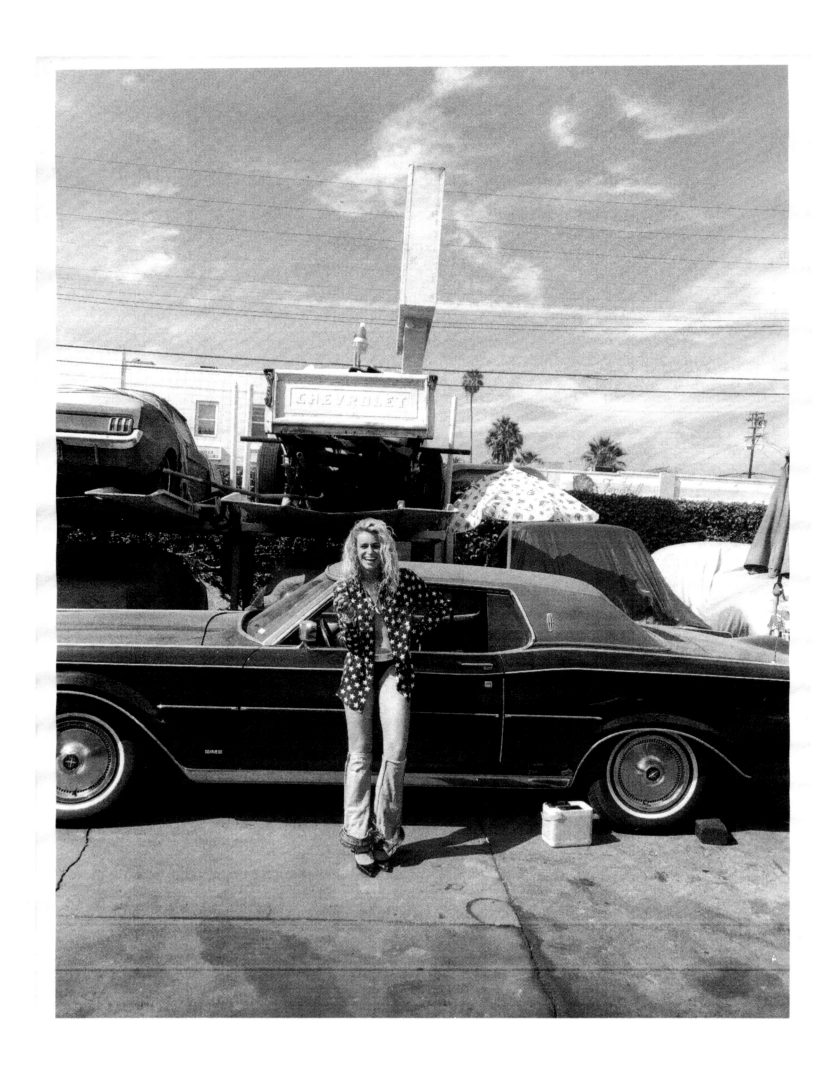

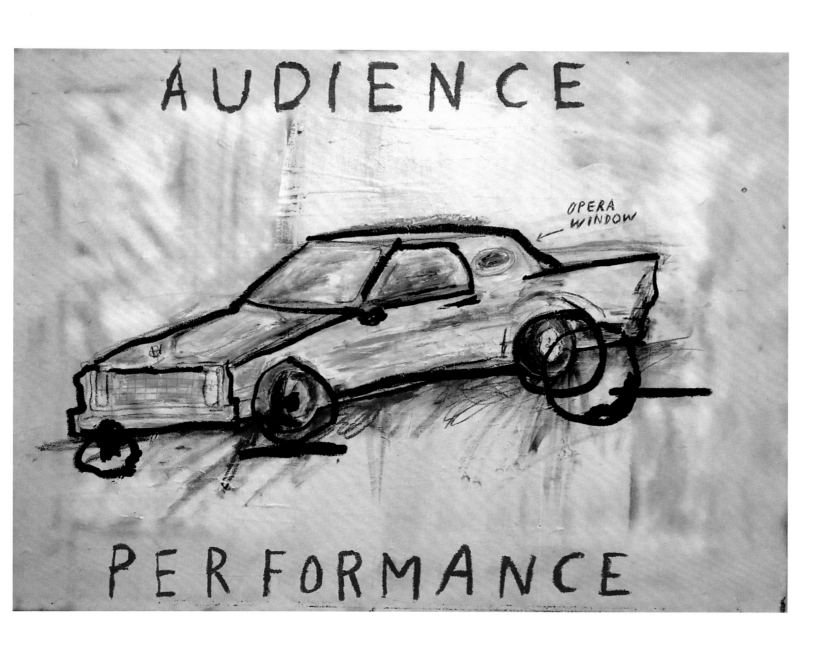

SUNDAY STYLE

I hung out at a lot of car dealerships when I was a kid. Chrysler. Ford. Buick. Pontiac. Cadillac. Dodge. Chevy. They had these weekends for families. They'd have a hotdog stand, free hotdogs. Free soda. Free popcorn. Balloons and raffles. Sometimes there'd be a big monster truck parked in the lot and you could sit in it's giant tires, eating your hotdog and drinking your soda and waiting while your dad talked business to people. I always noticed, when I went for a piss,- the posters in the bathrooms, of the half naked women in ripped t-shirts and short shorts mini skirts and crop tops blonde hair, big lips big tits long legs leaning on Corvettes and Chevy's and Fords and Buicks and Pontiacs and Cadillacs over hot coals of Goodyears and Firestones and Michelins, posing in the bright suns of paradise and photo studios and far away places. And it stuck with me.

HIGH PERFORMANCE

You are lost inside the body of it
You disappear for days and months
Taking on the problems of it
Letting them roll around in your head

Letting them live on the tip of your tongue
Melting into them
Biting down on them
Burning holes in the sides of your old self
with great abandonment
to get rid of you
to make room for new
instinct

You are lost inside the heart of it
Forgetting yourself and everyone else
Void of past- you are the present
Disappeared for days and months

Leave no residue on the glass
Leave no fingerprints behind
if the silencer is no good
you'll be born in the wrong time
half human half sculpture
part one without a punch line
without gas or any power
like a crook caught on a bad night
freezes-
is fucked

The only way it's gonna seem real
the only way they'll never know
is to be and become
nothing but a show

IN BETWEEN JOBS

Indignation is part of it. Disparate drinking is another. Feeling neither here nor there, all over. Imagining. Imagination around the clock. Imagining that there is no feasible, possible, or pragmatic way you could not be thinking the same thing I'm thinking right now. The train coming towards us that ain't slowing down. Watching the same psychic on television an' zoning out in the same shit-for-brains blue light.

Except you're not the one alone in a hotel room. You're not sitting there on the bed looking straight into it with nothing to do but sheet tangling and machete swinging. You're, how did you put it? Occupied. Distraction's bitch. In a sense. Your fort is surrounded.

Not me. I'm in full swing; At large. Full tilt. I'm all engines purring, fully locked and loaded, gonna be the next great prize fighter. I'm the one alone in a hotel room and I have time for this getting right business. Slamming my fingers in drawers for fun. In between jobs. Got some money. I don't need to participate on an earth level for a few weeks. I don't need *it*. I can hang out in parking lots. In between walls. I'm traveling light now, real real light.

You're wrapped up. Full a' youth and age, full a' fear and fury… rooting through the change in your pockets, counting it, heads or tales'n it. Places to be. People to see. Stacking it up even. Sleeping early. Drinking orange juice. Frying an egg. Speaking in dignified nouns and verbs. Flushing toilets. Getting along with people. Containing it. Maintaining time. Running back and forth across the plank but not jumping. Shedding skins like a desert snake, puking now and then, keeping horizons level, shaking hands without knuckles. That kinda stuff.

I love when it's like that-

But I fucking hate when it's like that.

What happens when you stop that, when you're in between jobs? Fall from that body and you're done with the corpse? Is there some kind of funeral? A great depression? Exasperation, indignation, disparate drinking? A hotel room late night episode of room serviced shit-for-brains?

Tell me about it.

It's Saturday though so it's OK to get drunk and jump. I give myself that. Things get stranger with time. Realer with absence. I've been everywhere, everywhere too much, now I have no destination. Where are my feelings? No train of thought I'm trying to keep. No champion, no guide. I want this to be awkward. This dead pan. This spaceland. I want to spin out now. I want to fall for something that makes all 4 corners of my mouth dry. There's a lot shakin' up inside of me and I don't have to be anywhere. I can just throw all my shit on the floor and leave it there. No one's coming over. I can let the universe tell it.

Blinding par cans. Echoing floorboards underfoot- the austere and the rock n' roll. The trained vs. the instinctual kind. Magic moments vs. blips and bops. I'm talkin' about *in it to win it* in ways nobody can capture or copy or… get it. The arsenal berserk. You win the lottery of … impermissible thinking jags. Sleep in the ejector seat. There are no state lines. Your kind. My kind. Yeah sure, I need your kind to let loose on. I look out for people like you. You? Who knows what you want. But you need to steer. Steer or else I'll go everywhere at once. Like an octopus splittin' up into single legs.

I'm addicted to it. You know what I mean? It is, by all means, a great frontier- face to face with your cool or hysterical captors. The stage. It's a mile high. Where easy love is the enemy, the Achilles heal, dead gravity. The desire and desperation for love makes us improve, reach further. But being loved too much too soon- makes us deteriorate, deliberate, tolerate strange people, hesitate over clean breaks, wait too long- suck.

You gotta know better. You can't have it both ways. But it always *is* both ways. I don't mind bad reviews. Despise me before you love me so that I might give you something worth having, show you something worth seeing, tell you something you don't know. And when I forget what I fucking said or did, you can play it back to me. Say, "SEE… *all the shit you did wrong!*" And I'll pretend to be interested. But I won't pretend to like you.

Our forefathers- in their missteps- made us step up, made us- rise from their ashes, -maybe. Our friends and lovers who screwed us- made us better understand the world. It's shady. Our heroes- who let us down the hard way- had us climb the stairs and the ladders and the mountains, to kiss revelatory vacancy, so we might understand the act of falling and failing and highbrow denial, - how to crash. We are blessed if we learn this young, or ever. Cos this always goes on.

You can't live your life *always* offended. Or you can. But's it way better to play dumb and just keep going... like a genius.

In between jobs, last few days I been smoking less and eating vegetables... in ways that make my brain feel fairytale and dada. I mean... maybe I'm doing everything half as much and everything else twice or three times more. Work. Is this work? No yes no. Self inflicted. My whole physical and mental feelings are changing. Like loose coins in a cup. Fast broken thoughts and dizzy highs... lots of energy, sharp sounds, eyeballs shooting out in all directions. Quite a way to... get around... physically flailing while my mind is busting out of my skull, teeth grinding, legs winding. Going fast.

But I dig being in the grinder. It's romantic not being able to think straight. You keep showing up in these fast edit visions. Hanging out like you're waiting for something. And I keep feeling the weight from all the way out, hot lights and pauses, ruminations and cotton on the body. Someone else's drunk. Someone else's fatalistic approach to cutting through traffic. It's as if I am training myself to feel and to see- something I need- something I missed- some part of me- some other way around- that gets me to a highway I've never had the pleasure on.

I'm not confident or bullshit enough to know if time is truly warping. Not only when you're up there... but especially in the car ride after. And what kind of thoughts jump through your mind when you wake up, about what you've got to do. Thoughts hanging there like clotheslines. You either use them with purpose or they snap your head off. I imagine it's not easy. I myself, black out easy. I just recall the poetry in it. Feelings of self-loathing and isolation, slippery fucked up little agonies of sorts, moments- difficult to get with and harder to live with. Ugly beauty. Spit flying out of your mouth. I'm real interested in the spit I guess.

My best gigs have been when I am in my worst way. Most unsure. When I can barely move before, from fear of not being able to execute my aims. The only real fear of dying I've ever had- is that kind. Not physically real in retrospect, but when it was beyond real. Bigger than me. Not a doctor in the house and not an answer to be found, it tugging at me internally, coming down on me like a landslide. The fear of not being able to do what I was born to do, or rather- what I at least hope I was born to do. To be wrong about that would be like dying. And you think punching walls will make ya live that much longer. All the while, the aim is always changing and the target's always moving. The root is not loyal to you, just because you're digging. It's its own thing. A true outlaw.

You know what I mean. Do you? It's not wind. More like brute muscle ripping you to shreds, internal avenues of horror. Trying to be great at something. -Sometimes gets a little bad and tragic. A gun to your head *inside* your head. It's ever so, you know, artistic... and whack job rustic, taking a taxi to a hospital in France for a skull x-ray cos you got these thoughts in your head that been holding you hostage... and you want to see if they show up sharp on film 2 dimensional. Broken nose? No amount of looking in a mirror tells you anything sometimes. These days. And other perverted jokes. Is this a pep talk?

I really don't know what tomorrow morning is gonna be like. The thought crosses my mind that it won't be great but that quickly goes. Probably a headache. Probably won't pick up the phone calls. Probably will clean up this room around 5 cos it's a wreck and it'll depress me too much to leave it like this. But you never know. This psychic lady on tv, everything she's saying, I really get her. She's talkin' to me and I'm jotting it all down cos I don't want to forget that the train's coming 'round the bend, to listen for the whistle getting louder. Cos the money's coming in and the love's coming in and I'm gonna change my ways and it's all *really* gonna be something great this time around. Right now, this bit, this dumb drunk night, in between jobs... I'll forget it like it never happened. Like it was never real. And you, you'll never know I was ever here.

-London, 2018

RETURNING THE SCREW

This ghost you call me
the me oh my
the life you saw me
speeding by
wrangled by cowboys
baited like fish
dripping like ice cream
down somebody's wrist

This ghost you call me
the you know who
the nights you caught me
speeding through
without my decoys
wheels in a ditch
naked and angry
dirty and pissed

This ghost you call me
doin' what I do
the outlaw's Harley
the other shoe
sure haunts ya badly
wearin' that perfume
you make it easy
to fill the moon

This ghost you call me
knows your tune
amplifes it
feedback loop
right back at you so flowers bloom
every violet hell breaks loose
Oh I'll drive all night- I'll drive straight through
anything
to return the screw

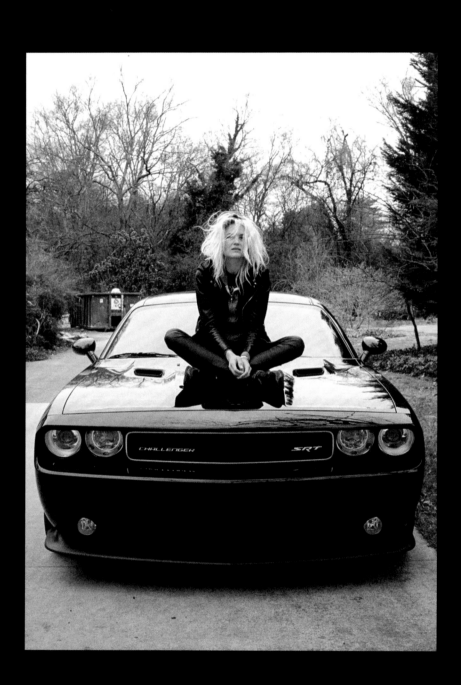

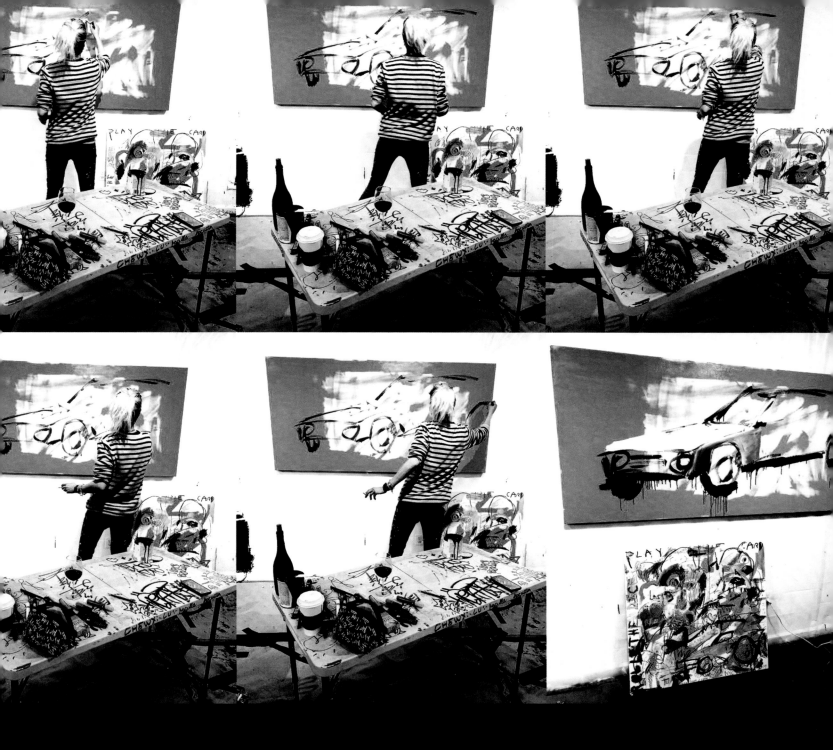
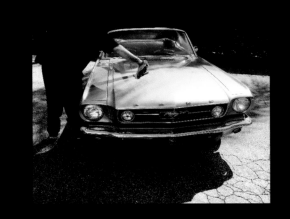

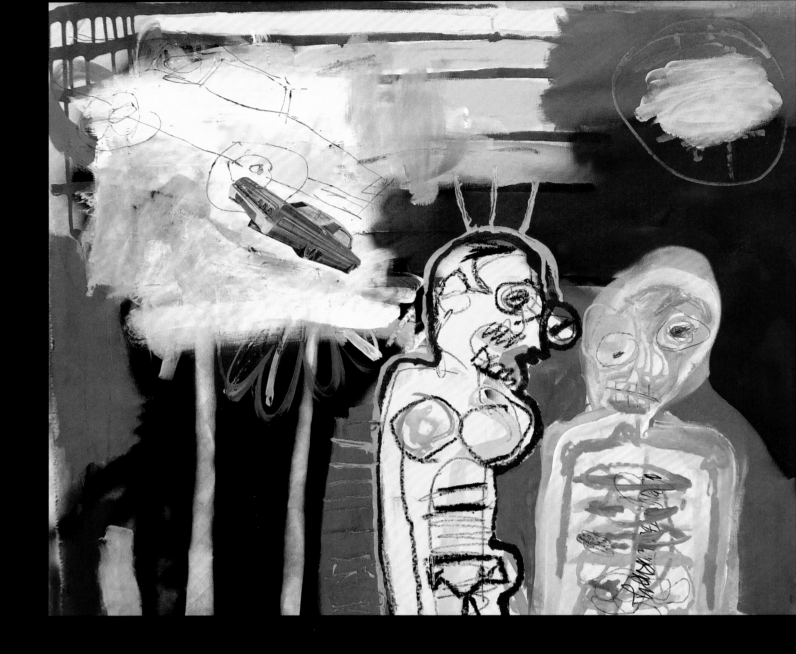

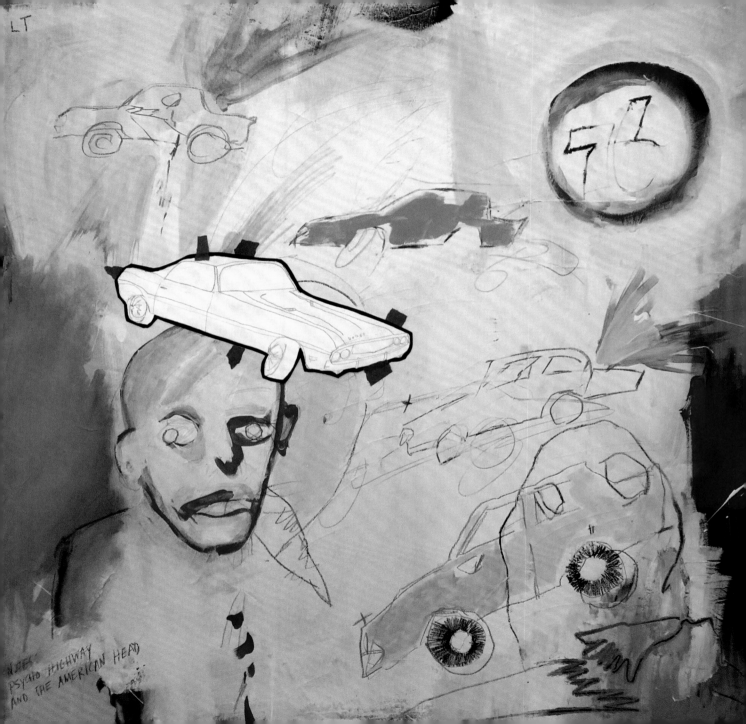

LT

NOTES:
PSYCHO HIGHWAY
AND THE AMERICAN HEAD

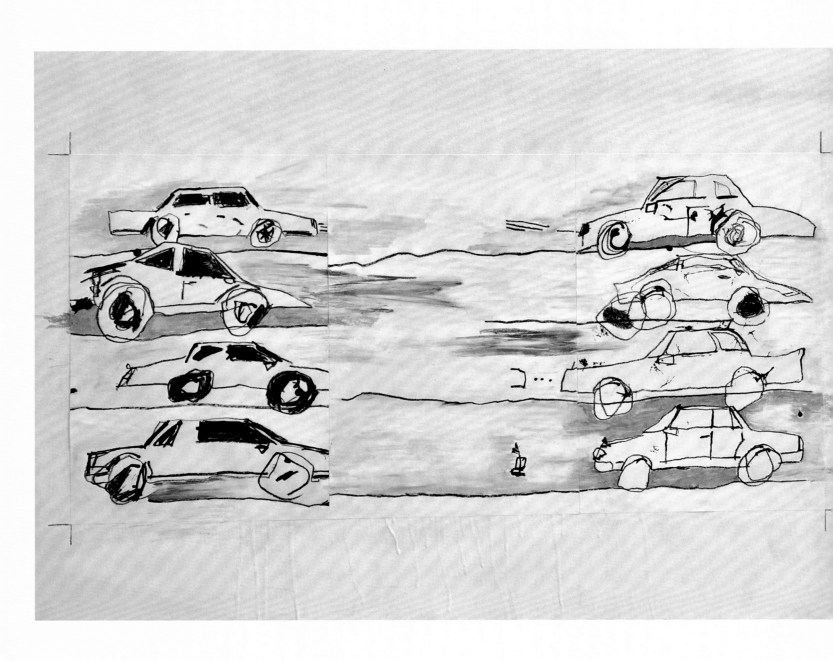

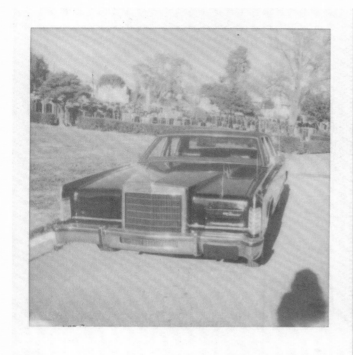

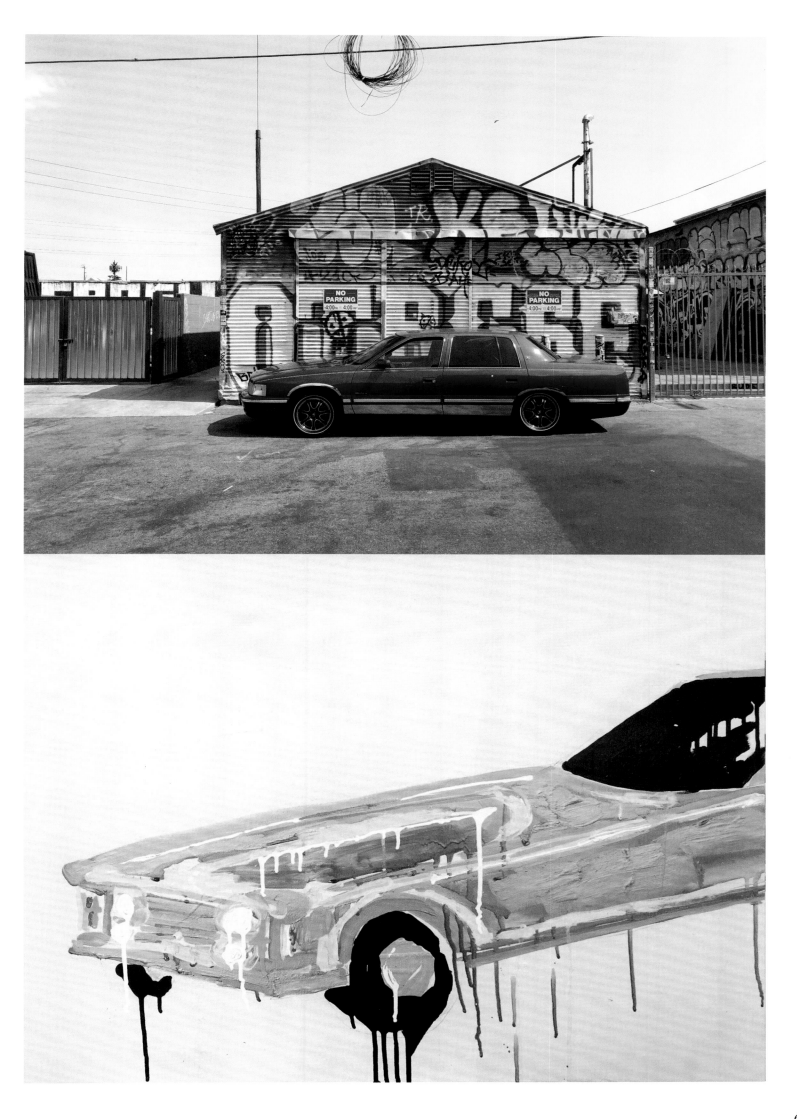

HIGH HORSES

galloping by
pulling faces
in windy St. Petersburg
drool

tops of trees are still-
but on street level
hurricaning
air and people
people and air and animal

Turisticheskaya politsiya
stagger
I don't speak Russian
or cop talk
can't copy that
nothing

The land swells
con los coches de policía
son por todas partes
real intimidating
sus coches estacionados
de lado
los hombres de pesadillas
pure shadow

Men with earpieces
autograph hunters
run you over
crushed ice
on sidewalks
sharks in the vodka

The Four Seasons here
is a yellow triangle
like Bermuda
full of the missing
Cubana is 'Cuban'

cigars the bar sells
long fingers on a napkin
rolled up and flown in
like how I'm feeling
too far now
from you

SUMMERTIME

Burning hot humid rabid vapid bug bite bee sting crowded overplayed delayed thirsty traffic

crazed stinky trashy melting moody bone soaked sweating

getting thinner and thinner and thicker and thicker

waiting forever fan hiss blade whirl predictable musty haze sea of eyes if i hear that question one more time I'll fucking

die swear on my life piss in the bushes fire in the hills shit on the sidewalk

drunk on the hood drugs in the pocket mud in the bed sick in the road

now, now, now, is it really

 sex? … are you strangers?

broken down on the side hit by a shiver live wires in water slipping and slid and licking and bit and lonely and slowly

goin' from dirt lot to dirt lot club to arena thru long halls of plastic

Nevada Coloradah

doors that won't close

doors that won't open

over exposed frozen in motion yo color like fever she could be your daughter just give us more ice we've seen it before

we've seen it all twice got the rhythm got riffs got 12 kinds of freak

in your eye

in your sky

like a crust of a pie

you're so thick skinned by now so thick skinned by now so thick skinned by now that by the end of the summer

done breakin' your leg all your right's a' been read all your bloods a' been bled

now, now, now, was it really

 fun?

EASTERN STANDARDS IN THE WILD WEST

Recently everything was on fire. The sky was black and brown. It was like pearlescent Armageddon. The sun was wearing a mask. And I felt like Dracula. Wearing his cloak. The sky clinging on to me, even while driving. Driving down the hill to West Hollywood to meet up, driving down and then west where the big cigarette was burning. It was coming in through the air vents and the doors of the car. You couldn't escape it. You could smell it and taste it. Everything was covered in ash. LA- a big ashtray. Lawns looked like winter on the east coast.

Dracula goes skiing.

And at the same time...

I was reading a great book that took place in Manhattan in the early 2000's. Deep in it, I got lost in New York for a couple of weeks, went back in time, remembered being around then, seeing the main character in the novel walk in and out of the lobby with a puppy. I remembered the dog cos it was cute and always pissing up and down 23rd street. I remembered the man because I'd seen him in films. All of that was true.

But the rest was new- a story unfolding under the same roof at the same time I was there, back when I was young and oblivious to anything but myself. Back when I was living in a hotel going nuts. Going fucking bananas. Going bananas just like the main character. But for completely different reasons. In completely different orbits. Stepping in one another's gum. I was 23. Hell if I ever went to bed before the sun came up. Totally vampiric. Totally wired.

Hanging upside-down.

Now I'm back and I'm right side up.

And I can feel the cool glass of those lobby doors on my fingers. The way the wind made them heavy and the air-conditioning hit me. Now with revelations. Multiple visions. Painters and misfits camping out in the lobby. Tales of innocence with high doses of interference. Hey Stanley. Where's Victor? I don't have the money yet. The past is in the present tense. Not sure if it's Eastern Standard. Not sure if it's the wild west. I'm seeing double reflections in the glass as I push open the big doors...

on LA from New York. LA, on fire and New York, nearly 20 years ago when I left my guitar in the back of a taxi and cried and ran after it. Now my car is covered in ash, and it looks like winter long before winter, looks cold and feels hot, and I'm on chapter 10 and I remember the way the light was in New York *then* and it looks just like *this*. No different in the way it feels. No different in the way it hits you like somebody's knocked straight into you. I haven't changed at all. I am exactly the same. Still losing my balance. Still looking for answers. Awake all night then, and up all night still. It was always dark. It's always dark now. I was Dracula and hungry. I still am. Everything was foggy and smoky. It still is. I'm still there. I'm right here. My imagination needs no stretching. I am alive in every word. Decades are fusing. But it's not as confusing as you think.

I kept reading. And the fires kept going. Gathering momentum, chewing up houses and landscapes and highways. Spilling into the ocean and jumping right back out again, a fire wall full of crazed eyes on acid. Nature's toll tide. And people were running as fast as they could from its grasp on the past. Mourning and running and gettting their feet stuck in it. Trying to move on, trying to make it to the next decade without losing their lives or their minds or their jobs or their families. Sometimes losing.

And as I was running down 23rd chasing after my guitar, my cloak flapping wildly behind me, I leant down to pet the puppy and remembered- what I was thinking through the smoke and the screaming, some club I had to be at later, the mundane, the human, some movie I was half living. The leaves were green but winter was coming. The snow was coming. The ice was coming. But I would be gone by then. And someone I didn't know would be sleeping in my bed, and touching on the glass, and calling it home, and getting drunk alone at my little table, and going down to the front desk to get batteries for my remote, bulbs for my lamp, picking up mail from my box, smiling, talking to my temporary guardian angels, taking my elevator UP. I stood on the balcony wishing I could stay forever. Me and my typewriter and the guitar I love... Where is it?

The Hollywood sign sat nestled in gloom. And foreign tourists couldn't quite get the photo. People were wearing face masks in the street so as not to breathe in the poison. I couldn't tell who anyone was. Doctors or patients. Realizing all sorts of things, all sorts of things at once. Remembering so many things I had let drift from my mind. Finding it fantastically strange how small the world is. How surreal the truth is. How fiction is fact. How life stands still even as life moves on. Our markers get blurred and our songs sing themselves. And in this wonderful way, perhaps, we really can be two places at once.

That whole November, I found all this refreshing, breathing air that stunk of rubber, somehow un-alienating. Even gang related. Easy and familiar. Like the look on that man's face when I caught up with his taxi and retrieved my guitar, wasn't shocked. He didn't bother asking how I found him all the way out in Jersey. He didn't question the obscurity. He was just happy to be home.

Los Angeles, Nov, 2018

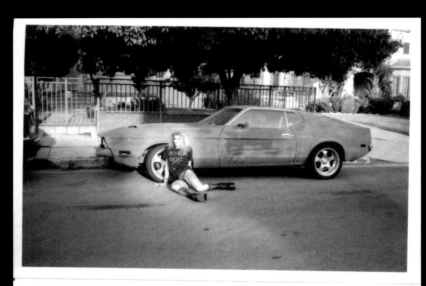

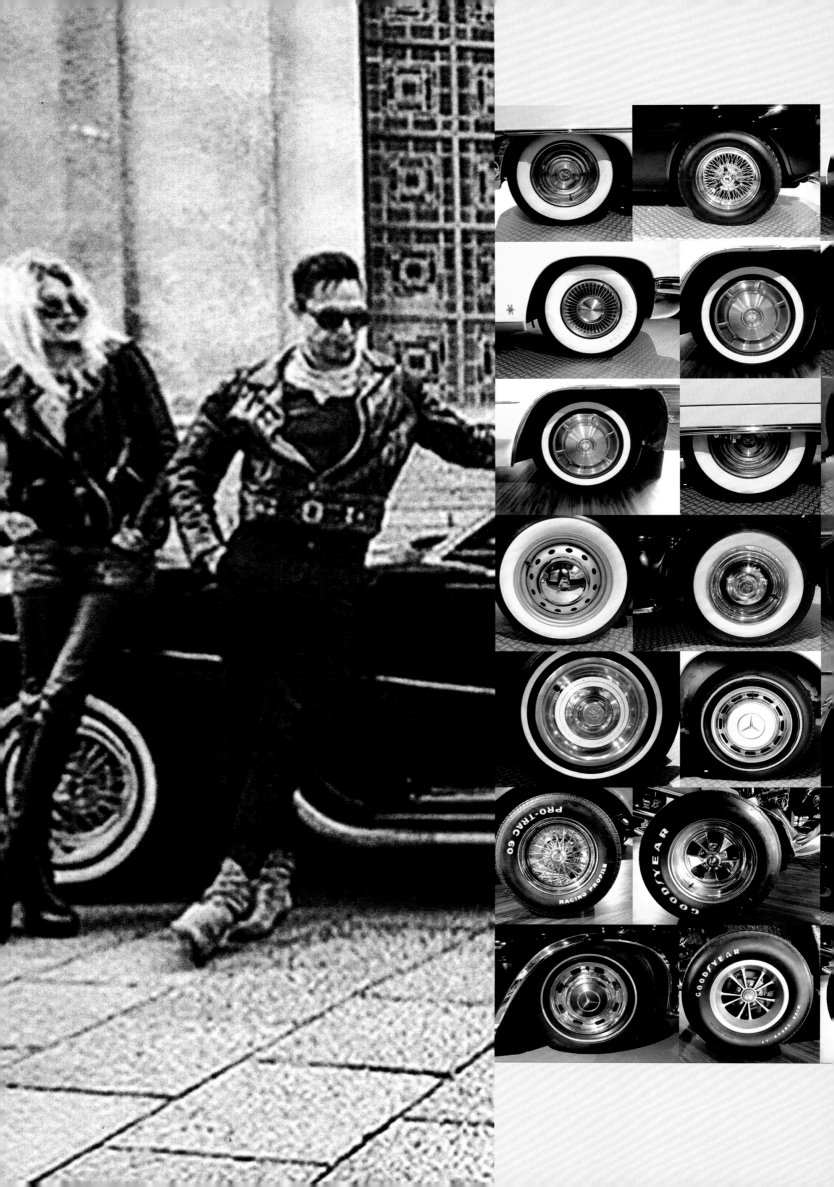

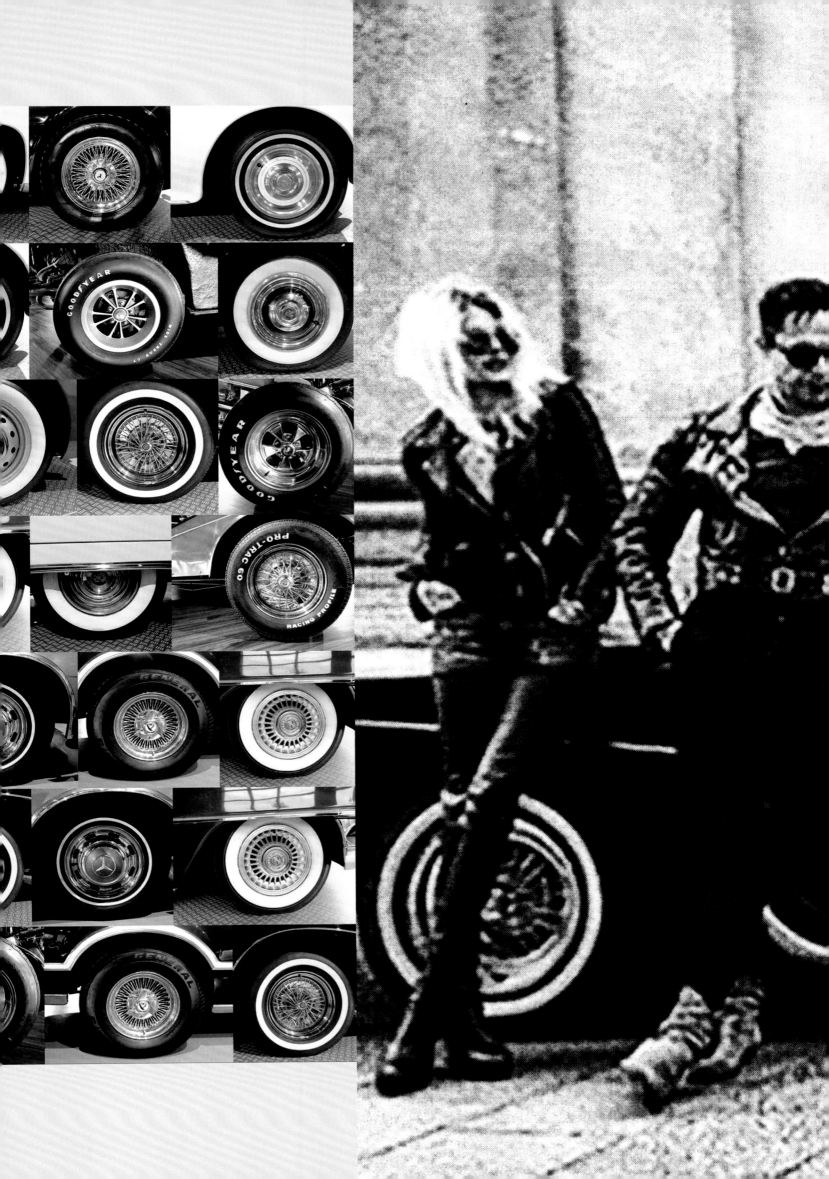

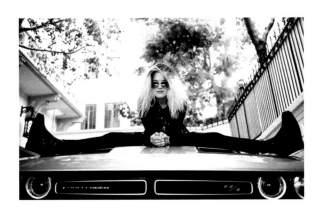

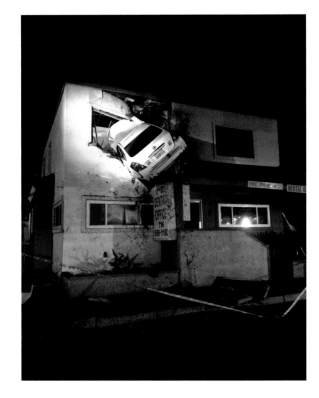

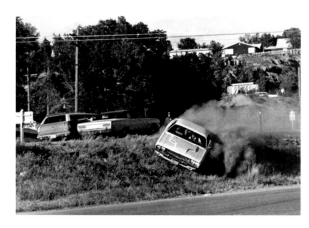

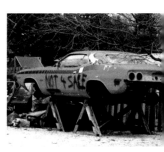

THE KILLS
Baby Says

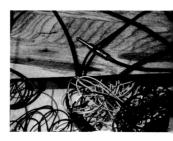

This one's for you Richard Prince ♡

DAUGHTER OF THE AMERICAN

USED
CAR DEALER

AM

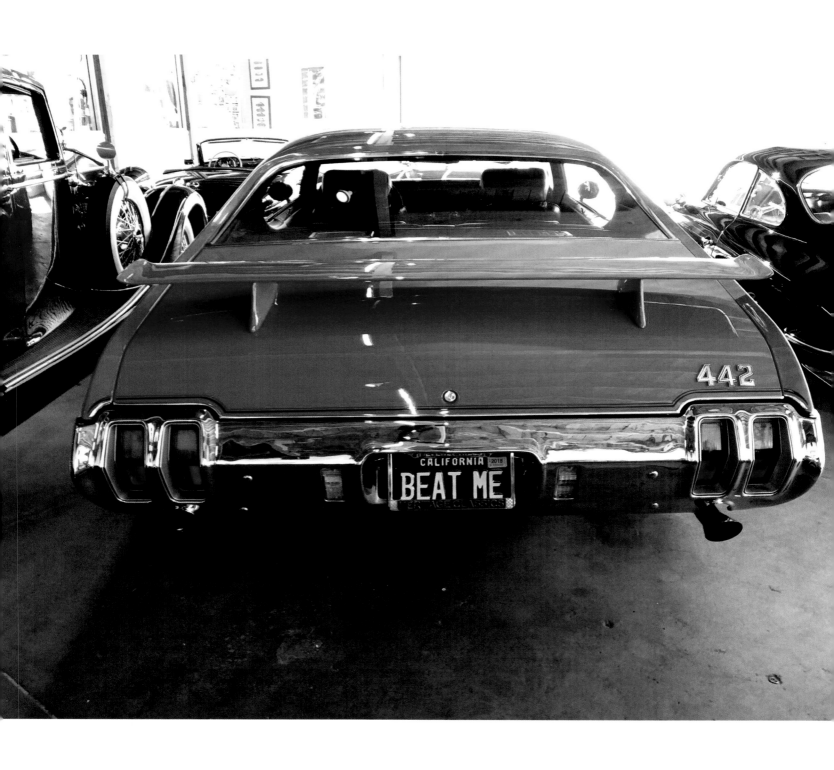

EAT ME

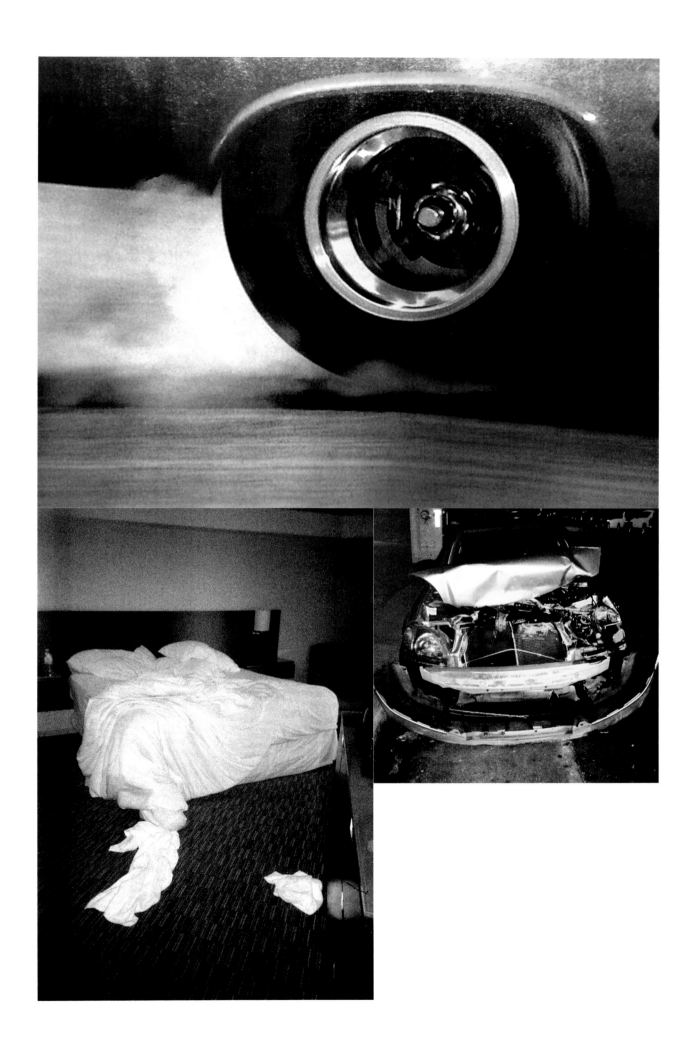

THE ELECTRIC SADS

Out in the flats in Inglewood, Los Angeles. Any neighborhood with brutal white light. No sun cover. Brown lawns. Two bedroom houses in faded sun colors. During the hottest part of the afternoon, two women stand on the sidewalk and talk.

NEIGHBOR ONE: So glad I ran into you I've been meaning to call.

NEIGHBOR TWO: Hello!

NEIGHBOR ONE: Robert's been all up in my hair an' bad moods all the time and I don't know probably because of the job and everything with that. An' Cathy is killing herself with the kids an' it's all been a lot. But Rosanna told me last week about Janey and Frank and the 442…

NEIGHBOR TWO: Oh?

NEIGHBOR ONE: that with the financial situation the way it is and the midlife crisis all over I guess, he's looking for a buyer.

NEIGHBOR TWO: He is? I saw him driving it yesterday like a crazyman, doing burnouts down on San Vicente with the guys...

NEIGHBOR ONE: *You* know the 442, the cherry red one. You know the one.

NEIGHBOR TWO: I know. It's *very* loud.

NEIGHBOR ONE: Oh isn't it! Just beautiful. Just *mean*. I don't really have room for it but I'd get rid of everything else. I'd *make* room for it.

NEIGHBOR TWO: Yeah? What are Cathy and Robert saying? Where are they gonna go?

NEIGHBOR ONE: They'll have to move I guess. I mean, they're bound to understand it. Been in my reoccurring dreams at night. That cherry red 442. They're bound to understand it.

NEIGHBOR TWO: You think?

NEIGHBOR ONE: Sure. Right? I mean, their Prius is paralyzing my land value. It's devastating my life span. It's killing off my love life. You can *see* that. They know this. I told 'em. They know I get *all the sad feelings* about it.

NEIGHBOR TWO: I love my Prius.

NEIGHBOR ONE: Do ya? Well, I don't have Janey and Frank's number. I don't really know them. And I heard he has to sell but he's stalling. Has all his *own sad feelings* when it comes to it. And I think I could help with that. I'm just the right person don't ya think? Ta' ease the pain?

NEIGHBOR TWO: I can ask.

NEIGHBOR ONE: That'd be great if you don't mind. Would take *real* good care of her. Be sure to say that. Wash her on Sundays. Oil changes early. All the fluids. Air in the tires. Hand waxes. Vacuum service. I mean I would need to get rid of everything *else* first but I will.

NEIGHBOR TWO: Robert and Cathy. The kids and the dog...

NEIGHBOR ONE: Oh they'll be fine, they'll figure it out. They've saved a lot of money driving that thing. That electric pancake. That oversized Reebok. They've been saving and saving and saving the planet and saving themselves. All good on 'em, I get it, I just ...

NEIGHBOR TWO: *Good* for them.

NEIGHBOR ONE: - can't take it anymore! I pull into the driveway everyday and I just want a sledgehammer. I just want to kill it. It's always sitting there just looking desperate. Gives me those *sad feelings*.

NEIGHBOR TWO: You *do* seem...

NEIGHBOR ONE: Look at me aging! I'm so tired of the silence. No sound. It's so sick. It's *toooo* creepy. Feel like I'm disappearing. I need to put on a few pounds, build my muscle back, feel the horses kick. I gotta get...

NEIGHBOR TWO: Healthy?

NEIGHBOR ONE: *HEAVY!*

Vanishing Point Script 1971 (Siren) (Siren) Wonder what's goin' on. Here comes CBS News. Must be important. Unit 2473 to helicopter. - Helicopter, over. - Have you located suspect? Suspect under surveillance. (Sirens) Helicopter one to 2473. Suspect stopped. He can't get away. All right. All right, maintain surveillance. (Train bell) Kowalski! And the keys for a sawed-off weekend. Well, you're both welcome. - What have you got goin' for Frisco? - You're not goin' back tonight? Hey, you're gonna kill yourself someday, you know that? - Do you know? - Yeah, yeah. Look, why don't you stay over till Monday, huh? - So you can go home right now? - Oh, yeah. Sure, sure. Just before midnight. Hey, look. Ya know somethin'? When the clock strikes 12, my car turns into a pumpkin. - Hey, Sandy. You know you're a born actor? - Yeah. Sure, sure. That's what my wife'll say, when I tell her I've been waitin' up for you all night. Hey. Look, look, seriously. Look, why don't you stay over? - Nah. - You can do with some sleep, can't ya? Look, I gotta get started out tonight, Sandy. Now which car? Which...? I can't believe it, could it be I've gone astray? Oh, Lord, won't you help me to find myself a place to pray? Hey, K. (Laughs) What's happenin'? What's happenin'? What d'you need? - Speed. - Why not? Hold that. How you doin'? - Fine. How are you doin'? - Lookin' good. Say when. - Oh, oh, oh. That's good. - Mm-hm. - Hey, man, hold it. I'll get you some water. - That's OK. Forget it. - You sure? - Yeah, I'm gonna split. - Hang out for a while. - Uh-uh. I gotta get moving. "Gotta get movin', gotta hit the road." Bullshit. What about them two chicks over there to slow you down, huh? - Yeah, they're beautiful. - So drop out and join the cause. No offence, but I gotta be in Frisco at three tomorrow. - Ah, you're puttin' me on. - Wish to God I was. You're bullshittin' yourself. You cannot make it. - Wanna bet? - This must be a souped-up somethin'? - Yeah, it's hopped up to over 160. - Whoo! But even so... I'm gonna bet you the tab for the bennies. I'm gonna be in Frisco, and I'm gonna call you at three tomorrow. Now, if I don't, double the deal next time around. - Bet? - Bet. Good luck, buddy! (Dog barks) (Farming report on radio) This is consistent with similar studies conducted elsewhere around the country. On the other hand, some other traits, such as fertility, calf survival rate, bull inheritability, heterosis or hybrid vigour may be an important factor in these latter traits. To cross even genetic unlikes produces heterosis, for less crossbreeding. So, just a few views of what's to come, and what will be seen in crossbreeding, from the day's farm report. - Ten seconds, Super. - (Va Savoir "Super Soul Theme" by the JB Pickers) You got it. Ah! Good morning, folks! This is yours truly, Super, Super Soul! Direct and live with no net, early people. Without a net! Transmittin' from KOW, spelt K-O-W, uh-huh, the noisiest, bounciest, fanciest radio station in the Far West! Now, let's cheer up the mornin' with some wham, bam, zoom, boom, wake-up music, with a little help from my friend! Now take it away, amigo! Hey, hit it! All right! Hubba, hubba! ("Got it Together" by Bobby Doyle) Takin'me on home! We got a long way to go today, baby! I just got a feelin'like my life was new And this is my first day She said she loved me, but she started to show me in a personal kind of way - Ooh-ooh-ooh, ooh-ooh-ooh - Oh, oh, yes - Ooh-ooh-ooh - Oh, now - The girl has got it together - Got it, got it together Hey. Pull over. - The girl done got it together for me - Got it, got it together And that's how it's gonna stay - Let me say the girl has got it together - Got it, got it together - I said the girl got it together - Got it, got it together - I said the girl done got it together for me - Got it, got it together And that's how it's gonna stay - Ooh-ooh-ooh, ooh-ooh-ooh - Oh, oh Wake up, now. Hey! Pull over. Pull over! You son of a bitch. - Whoa, whoa now - Ooh-ooh-ooh Ooh-ooh-ooh She turned me inside out with a kind of love You just can't hardly find She's got the kind of lovin' that could keep... One rider is up, moving to his bike. There is a yellow flag. In this race all riders will hold their position. Kowalski also is up and moving to his bike, he's firing it up and he's back in this race. - You OK? - OK! Get him! Get him! - Yeah, the girl got it together - She got it, got it together And now, crashing into the top ten, comes the first really monstrous hit of the '70s, a number that all by itself jumped 29, 29 places in one week! Uh-huh! There's absolutely no doubt whatsoever, as they say, that this will be next week's number one! Numero uno, baby! The itchybang entitled "Where Do You Go From Here, Baby?" by Brian Obine! Sock it to 'em, Brian, baby. All right, get to it! - Christopher came in the name of Spain - Yeah! - In 1492 - Sock it to me! Talkin' to me, now! He said "I think the world is round and I believe I can prove it's true" The waters raged and his ships waylaid But onward Christopher came His desperate dreams finally climbed ashore And the world's never been the same - Hooray for the men of vision - Hooray now - Who are never satisfied - Ooh-ooh-ooh Who believe the way to move forward - Is to give it a better try - Give it a try - Hooray for the men of vision - Hooray now - May they never disappear - Ooh-ooh-ooh Who live just to ask the question - Where do we go - Where - Where do we go - Where - Where do we go from here? - Where? Where do we go now? Where do we go now? Where do we go from here? Takin'a look through the history book It's amazing how far we've come Now some folks say there's no more to learn Others say we just keep goin' We've explored the world from inside out (horns blare) - Hooray for the men of vision - Hooray now - Who are never, never satisfied - Ooh-ooh-ooh Who believe the way to move forward - Is to give it a better try - Give it a try, now - Hooray for the men of vision - Hooray now - May they never disappear - Ooh-ooh-ooh They live just to ask the question - Where do we go - Where - Where do we go - Where - Where do we go from here? - Where? Where do we go now? Where do we go now? Where do we go from here? - 123, what's your location? - We've been in a two-bike pile-up on 53. - Ten-four. How far out are you? - About five miles from Thompson. - Can you give me a description on the car? - 1970 white Challenger. Colorado licence OA-5599. - Ten-four. Was anybody injured? - No injuries. - Ten-four. Return to your station then. - OK. We're on our way in, but you'd best send a truck for that other motorcycle. Supe. Pick up on this, man. "Attention all Highway Patrol stations." "Suspect vehicle, 1970 Dodge Challenger, white in colour." ("Freedom of Expression" by the JB Pickers) (Truckdriver honks) Car number 71 just crashed into car 63. It's a pile-up. Eight cars... nine cars! Oh, my God, it's number three, Kowalski! Look at him riding on the roof of the car. Greetings, sir. Let's race. You got any balls in that mother? (Laughs) You bastard. (Sirens approaching) - Car 24 to headquarters. - Come in, car 24. Yeah, we lost him at the Nevada border. Let Nevada handle it. This guy's nuts. Ten-four. Will advise Nevada Highway Patrol. ("Welcome to Nevada" by Jerry Reed) Yeah, I got it all right. Initials OA-5599 Colorado plates. Now, what's this roadrunner done, fellas? Hey, Supe. I got them on the air now. Yeah, quite a mother. But fellas, as you know, we can't throw anything at him except dangerous driving and failure to stop - misdemeanours, both of 'em, over here. Yeah. But you told me that once, camarada. But has this bronco in the Jaguar filed a formal complaint? - No, he hasn't. - There you are. That isn't even a felony. - What are you gonna do about it? - He hasn't got us bugged

any. He's the one that's gonna have to start worryin', as of now. - Good luck. - Yeah. Don't you
worry. We'll catch him. (Honks) May I help you, sir? May I help you? - Yeah. Fill her up, please.
- Thank you, sir. Come on, will ya? Relax. I'm not going to hurt you. (Gasping) Come on, baby.
You play ball with me, I'll let you go, huh? Come on, tell me. Where do you get the stuff? Huh?
Which house? Come on, come on. Get out of here. Get out of here. Go! And there goes the
Challenger, being chased by the blue, blue meanies on wheels. The vicious traffic squad cars are
after our lone driver, the last American hero, the electric Shinta, the demigod, the super driver
of the Golden West. Two nasty Nazi cars are close behind the beautiful lone driver, the police
numbers are gettin' closer, closer, closer to our soul hero in his soul-mobile. Yeah, baby. They're
about to strike. They're gonna get him, smash him, rape the last beautiful, free soul on this
planet. But, it is written: "If the evil spirit arms the tiger with claws, Brahman provided wings
for the dove." Thus spake the super guru. - Did you hear that? - Yep. Where the hell'd he get so
much information? Same place as you do, Charlie. - You mean from our own frequency? - That's right.
How long's he been at it? Year and a half, maybe two. Hell, that's against the law. - So's
carryin' a transistor on duty. - Hey. C'mon, now, that's different. But he never says anything to
incriminate himself. Brains and lawyers, Charlie. As far as the law's concerned, he's clean as
Kleenex. It's true, true, true, true, true, my friends. For, by the latest information, our soul
Challenger has just broken the ring of evil the deep blue meanies have so righteously wrought. Get
through 'em, baby! Get through 'em! Friggin' faggot. Attention. Calling car 44. Attention, car 44,
do you read me? Gimme that. This is car 44 reading you loud and clear, over. Where are you, car
44? We're on 80, some ten miles from Argenta, over. Oh, good. Stay with it. Watch for a white
Challenger, licence plates initial OA-5599. Colorado plates. Last seen heading for Dunphy on US 40
at cruising speed. We have reason to believe it's supercharged, so maintain double alert till you
spot it. Then call in for instructions. Over and out. Let's go. C'mon, let's go. - What do you
think he's done? - Don't know. Well, what do you think? I think he's gonna hijack that car to Cuba!
- Don't be ridiculous. - Hell, Charlie, I don't know. Maybe killed somebody. Maybe stole that big
dude of his. Maybe both. ("Runaway Country" by The Doug Dillard Expedition) Hey. What's he doin'?
Jesus Christ. Watch it. Watch it! Watch it! Move over. Let me take it! Let go. Let go! I'm gonna
get that son of a bitch. So help me, I'll get that son of a bitch. Hello, Nevada? Hello, Nevada?
Nevada, this is Colorado State Highway Patrol. This is about a special query raised by the Utah
Highway Patrol. That's correct. But later they asked that the information be forwarded to you guys,
so get ready for some details. Put on your tape recorders and all that sort of jazz, huh? This
speed maniac you've been chasing all over your territory is a former professional road racer named
Kowalski. K-O-W-A-L-S-K-I. Repeat, Kowalski. First name unknown, other particulars also unknown.
All we do know is that he's employed as a car delivery driver by an agency in Denver. He's presently
driving a Dodge Challenger, Colorado licence plate OA-5599. This is not a stolen car. He's driving
it to San Francisco for delivery due Monday. It's only Saturday. What's his hurry? That's what we
wanted to know ourselves, so your guess is as good as ours. Ten-four. - You all right? - Yeah. 44
to headquarters. 44 to headquarters. - He's... I lost him. - What? - Headin' for Tonopah. - What's
goin' on, Collins? - Where the hell are you now? - Are you crazy? Correction. We're still after
him, we haven't lost him. Now come on! Stay right where you are. We're comin' to you right now.
Come on! Let's go, let's go. Gimme that. - Car 44 to headquarters. - Come in, 44. He's jumped the
main road and headed out into the desert. I'll let him cook out there for a while. He ain't goin'
nowhere. What's he tryin' to prove now? - Any time now, Super. - Yeah, yeah. Run a tape. - I
already ran a tape twice. - Are you blind or somethin'? Can't you see I'm thinkin'? Crazy.
Kowalski. Kowalski, can you hear me? Do you hear me, Kowalski? Now, I know you can hear me,
Kowalski. I'm sure you hear me now. This very minute. Now, you listen very carefully. The whole
mobile force of the Nevada State Highway Patrol is after you. They waitin' for you to come up for
air. Yeah. Now, some people imagine you'll try to get to California through Death Valley. And
others bet you'll die there in the desert. These few are just too happy to see you vanish for good
out there. But my tape deck is just as jammed with telegrams as my head is jammed with phone calls
from people who are wishing you well in your getaway, no matter where it might lead you. I wish I
could help you, but I can't. I can't. I don't think anybody can, except for that crazy lucky streak
of yours. And now you're gonna need more luck. All of it, perhaps, and badly. You can beat the
police, you can beat the road and you can even beat the clock. But you can't beat the desert.
Nobody can. You just cannot. (Switches off radio) Go to hell. Wait! ("Love Theme" by Jimmy Bowen
Orchestra and Chorus) (Woman) I love you. Wouldn't it be funny after all if you did have to arrest
me? I mean, me trying to turn you on, and you trying to turn me in. I love this. I love your scar.
You hate it, but I love it. No, I don't hate it. I just hate what it means. What does it mean?
Only if you make war on war will you overcome it. I love you. I love you. - You're crazy, surfing
in the middle of winter. - I'm going out again. Maybe I'll catch an eight-footer. Oh! I'll ride it
in your honour. Sayonara. Remember me. Here we are at point zero where the Kowalski saga began. To
be interviewed by KLZ TV News is the owner of the agency, Mr Holly Makas, and one of the attendants,
Sandy McKees. Sandy, you knew this man best. What do you think of Kowalski? - He's a great driver.
- A what? - What did you say? - I said he's a great driver. - We knew that. - You won't find a
driver like him anywhere... But as a professional, he never really made the grade. Well, you know
why? He never really wanted to. So far as I'm concerned, he was number one then, and he is number
one now. (Cheering) Can't find a driver with his potential. Why don't they let him alone? Let the
guy alone! Look, he never done any harm. This is Bob Palmer of KLZ TV News in Denver. Super Soul
needs no introduction as our number one disc jockey, but he's on his way to becoming a national
celebrity in his own right, - as the invisible guide of Kowalski. - The blind leading the blind.
Kowalski was involved in a cross-country chase starting in Denver, Colorado. Stay right where you
are, son. Don't move, stranger. Don't move. I'll get him for ya. I'll get him. I'll get him. Stick
your pretty little head right through there, baby. That's it. Now we got him. Now we'll get our
basket over here. Look at that. Live and wrigglin'. Yeah, ain't that a beauty? Oh! Ain't that a
fat one, though? Now we'll get him in here. Thank you, son. That's got him. Thank you. How many do
you have in there? I've got six rattlers, two sidewinders, and now we've got one very precious
diamondback. - What do you do with those things? - Trade 'em. Trade 'em for coffee, sugar, chewin'
tobacco, salt, flour and beans. Lots of beans, son! You live out here, huh? Look, I'm lost and I
need your help. Attention Kowalski. I've got an important message for you. Kowalski, are you
listening? Now, dig this. Coppers from the Highway Patrol are combin' the desert, huntin'for you.
Listen carefully. Believe it or not, they tryin' to help you. They really are. Dig it? (Switches

radio off) - That depends, son. - What? You said you needed my help, so that depends on your helpin' me first. Helpin' me to get to where it was that... to get to where it was that I was headed for. One of them is... is a-comin' on, now. I can't see a damn thing out there. I'll bet you can't even see my truck neither, and that's... just over there. - Let's get the hell outta here, huh? - No, that ain't any way to do it. That's no... That's no way to get the hell out. No, the best way, to my knowledge, to get away, is to root right in where you are. Just root right in. They just went over, yeah? But stay put. Tracks. Let's get down and take a look. They must've found my old truck. He's circling out here. It's a truck! It's a derelict. Probably been there since the Depression. He's headin' north. OK. - Where to now? - Straight ahead! Name, Kowalski. K-O-W-A-L-S-K-I. Christian name... Christian name, my flat foot. What is it? (V"You Got to Believe") - What is that? - Faith healers. Don't you come any closer. - You wait in this automobile, you hear me? - OK, partner. Them healers don't like strangers much, especially their deacon, Jessie Hovah. He's a... he's a mean one. - Yeah, don't forget about the gas. - I ain't forgettin' the gas. - You're late. - Mr Hovah, my truck broke down. - Who is that man over there? - Just like I was tellin' ya, my truck... She ain't gettin' any younger now, and... - Who is that man? - He's a friend. A friend, eh? How do you know? Ain't that a pretty one, though? Ain't that real pretty? Yeah. But we don't need 'em any more. Look. I told you these meetings are private. - Why did you bring a stranger here? - Mr Hovah, I didn't bring him. He brought me over. - Why? - Well, he needs some gas. Gas. You just take your gas and take him out of here. But, Mr Hovah, ain't you gonna give me my coffee and sugar and all the... Yeah, you'll get it. ...all the stuff that you promised me? - You'll get it. We just don't need the snakes any more. We got the music. So, we are going to... free the vipers! I think she's pretty much filled up now. Yeah. - Well, you can leave now, son. - How? Well, just follow the larrea belt. - The what belt? - The larrea belt. I mean, always keep your eye on the trail of the sun, and never lose your shadow. Well, then, when you see very tall saguaro cactuses, don't lose them neither, cos that's the larrea belt. The saguaro and a creosote tree'll take you right back onto the trail of the earth. Uh-huh. So that... that's the road? That's the road, yeah. You're beginnin' to get the fundamentals of it, son. Maybe. Well, thanks, pa. Thanks for everything. You're very welcome. Hope I'll be seeing you again. ! Vaya con Dios! Enlisted in US Army 1960. Service in Vietnam War. Wounded, Mekong Delta. Honourable discharge from army, 1964. Medal of Honor for bravery in battle. Entered San Diego police force, 1964. Twice promoted, detective first class 1966. Dishonourable discharge. Classified documents available to authorised personnel only. Demolition derby driver and auto clown 1967, '68. Driving licence suspended 1968. Previous failure to submit to alcohol-level tests. Minor jobs, other driving jobs from 1970 to date. Additional data, none. - Ready now? - Not yet. Not yet. - Well, just tell me when. - I'm ready, but he's not ready yet. - What? - Forget it. I'll tell you when I'm ready. For heaven's sakes. Oh, come on. - Push it. - I am pushin'. There's a car coming. Be back in a tick. Oh! What a relief. Yes, thank you. You're very kind. You're welcome. Pardon me. Could you please tell us in which direction you're headed? - I'm goin' to Frisco. - Oh, well, that's perfect. Thank you. Is something wrong? - No, why? Should there be? - Well, you're so silent and moody. Maybe it's just part of my nature. Why are you laughing? - I'm not laughing. - Yes, you are. Way down deep inside yourself. It's because you think we're queers, isn't it? Hey... This is a stick-up. Stick-up? Why are you laughing, Mary? Well, tell me. Tell me! No, no, no, please. It hurts. Oh, my hair! Oh. You bitch! (Va Savoir "So Tired" by Eve) - Hey, brother K. - Hi. - Welcome back. How you feelin'? - Tired. Oh, I bet you're tired. I bet you're tired. - Well, you wanna know what's happening? - Yeah. What's happening? Big Brother's not so much watching as listening in, as you well might have gathered by now. But what you probably don't know is that they found these two, let us say, "gentlemen" on the road. They was pretty badly battered up. Yeah. They musta had an accident or something like that. Some smartass was puttin' pressure on them to charge you with some ugly, nasty crime. Let us say assault and battery. But the two gents in question refused to comply. Or, as my alter ego might put it, stickin' to their guns. Now, listen to this. Some party or parties are busily preparing a little welcome committee in the Sunshine State. The main doors, and even some side doors, are heavily embellished with goblins and fuzzy frills. - You know what I mean? - Yeah, I know what you mean. Hang on now, brother, hang on. ("Dear Jesus God" by Segarini and Bishop) All right, everybody, clear the streets and you won't get hurt. Hey! Hey, nigger! Hey, loudmouthed nigger! I'm gonna shut your big black mouth! Let's get him! (Music cuts off) (Changes radio stations) (Turns radio off) Kowalski! Hi! Hey. - Hey, you need any help? - No, thanks. - Sure? - Yeah, I'm sure. - Far out, man. - Hey! Wait a second. - What? - You got any ups? - You mean speed? - Yeah. Yeah, I got some back at the place. - How far is it? - About a mile. OK. You wanna go back? Far out. Know what I mean? Mississippi Queen She taught me everything Way down around Vicksburg Around Louisiana way Lived a Cajun lady Called the Mississippi Queen You know she was a dancer She moved better on wine While the rest of them dudes was gettin' their kicks Brother, beg your pardon, I was gettin'mine Mississippi Queen If you know what I mean Mississippi Queen She taught me everything This lady, she asked me If I would be her man You know that I told her I'll do what I can To keep her looking pretty Buy her dresses that shine While the rest of them dudes was makin' their bread Brother, beg your pardon, I was losin'mine Thanks. - Do you want more water? - No, it's OK. - You keep these. I got a whole bunch of 'em. - Oh, no, no. I can't use all of that. Well, take what you need. - Thanks. - All right. Person-to-person call for Kowalski. Person-to-person call for Kowalski. Can you hear me, Kowalski? This is to inform you of the latest developments. Correction to my last delivery. All the main doors are closed except one. This one opens to Sonora. Oh, far out, man. That's just a couple of minutes up the road. You're gonna make it, Kowalski. Yeah, the last chance. Hey, you, uh... you familiar with this jock's voice? Super Soul? Yeah. Why? ... highways and byways and freeways. I said freeways... - I don't know. - That's Super Soul. ... spot our hero out there on his lonely... - Maybe he's got a cold, but that's his voice. - Help the man. - You really think so? - Cheer him on and let us know where he is... - Wait a minute. - ... so I can personally deliver your message... - Hey! Come here! - ... of goodwill to our soul hero. - Are you listenin'? - Come on! We're gonna help you. Dig it? All of us. - Listen to this. - Yeah. So, friends, call me. - Yeah? - Yours truly, Super Soul... - Whose voice is that? - Super Soul. Who else? - You sure? - Course I am. - You absolutely sure? - Well... Hang on a minute. Brother K, just keep the faith in us, baby, and we'll lead you right on to glory. Yeah, it sounds a little different. He sounds kind of stiff, or square. He sounds a little mechanical. - You sense a trap, man? - Yeah. Maybe. - You wait here till I get back. - Where you goin'? Just wait here. You gonna stay with us? No. No, I don't think so. Is there something I

can do for you? - Well, like what? - Like anything you want. No, I can't think of anything. - You don't fancy me? - Oh, yeah, yeah. Very much. - Then why don't we have some fun? - Thanks. Thanks just the same. That's OK. - Isn't there something you'd like? - Yeah. Yeah, how about a smoke? - Oh. OK, I'll roll you one. - No, no, no, no. No, a straight one. Yeah. All right. Here. Keep the pack. Thanks. - You know, you haven't changed much. - Hm? - I said you haven't changed much. - Haven't I? Here. That was a long time ago. I know. I pasted it up when it first came out. When I cut it out, I... It's a lot like shooting jack rabbits, ain't it? Goddamn, it's hot, I know that. ("Dear Jesus God") You're right, man. He sold you out. More cops than I ever seen, man! You were sold out. - What the hell's that for? - That's your pig pass. (Siren) (Siren approaching) It's police! Clear the road! Clear the road! Get those cars outta there! Get those cars back! That's him! That's him! Get those cars outta here! Get those cars outta here! Get after him! Get after him! Get those cars outta here! Move! Move! - Damn! - Hey, that's my car! This is California. We don't call them mothers or speed freaks around here. But we're gonna do what you haven't been able to do. We're gonna stop him for good. Yes, we've been previously informed of all that. Thank you, Nevada. Well, you don't need me any more. You're in California. You're almost home. Can you make it on that? You bet your ass, baby. Take care, Kowalski. Hey, K. I knew you wouldn't make it. What's happening? You happening, man. You all over the front page. Here's the headline. "Ex-Race Driver Involved In Massive Police Chase." Yeah, they even printed poor Vera's story, plus her picture. Hey, man. What you out there drivin' like a wild man? You know you're gonna lose your gig. It's not your car anyway. What you trying to prove, man? Are you high, or what? Hey, K. You still there? Look, just tell Sandy not to worry. I'm OK, and that car's gonna be delivered Monday, right on time. - You're gassed, man. - No, listen, it's... But it's double the bet next time around, huh? Hey, man. Don't do no silly shit out there, OK? - Take care of yourself. - OK. I'll see you, amigo. ("Sweet Jesus" by Red Steagall on radio) Now my soul is free from sin Since he opened up the door and let me in Soon I'll walk on streets of gold I'm a sheep in his great fold I'm no longer all alone Since sweet Jesus made me whole and led me home Ten seconds, Super. ("Sing Out for Jesus" by Big Mama Thornton) Sing out strong for Jesus Sing out for the Lord Sing out strong for Jesus All righty! Good morning to all you folks out there. Sunday morning here, with all men of goodwill, and some of evil will thrown in for good measure. All peace-loving Christians getting ready to go to church this morning, and here I am, yours truly, yeah, Super Soul, bantering the stream of unconsciousness and peddling his labels for the sake of good music to all you listeners out there. But I'm here on Sunday for the first time in my life, and for the very first time this KOW radio station begins, not only to DJ and to do my own thing, but to tell you a little story. Now let's start at the beginning. But before we start, here's some early Sunday morning wake-up music. Sing out for Jesus When you're tired and troubled, come to Jesus He's the man that really cares - Come sing this song - Sing out for Jesus Praise Jesus the Lord And today, in a beautiful gesture made by beautiful people, in beautiful downtown Goldfield, this radio station was named KOWalski, in honour of the last American hero, to whom speed means freedom of the soul. The question is not when's he gonna stop, but who is gonna stop him. ("Over Me" by Segarini and Bishop) Hello, Kowalski. Kowalski. Please listen, Kowalski. Oh, it's useless. Cut it off, man. Stop!

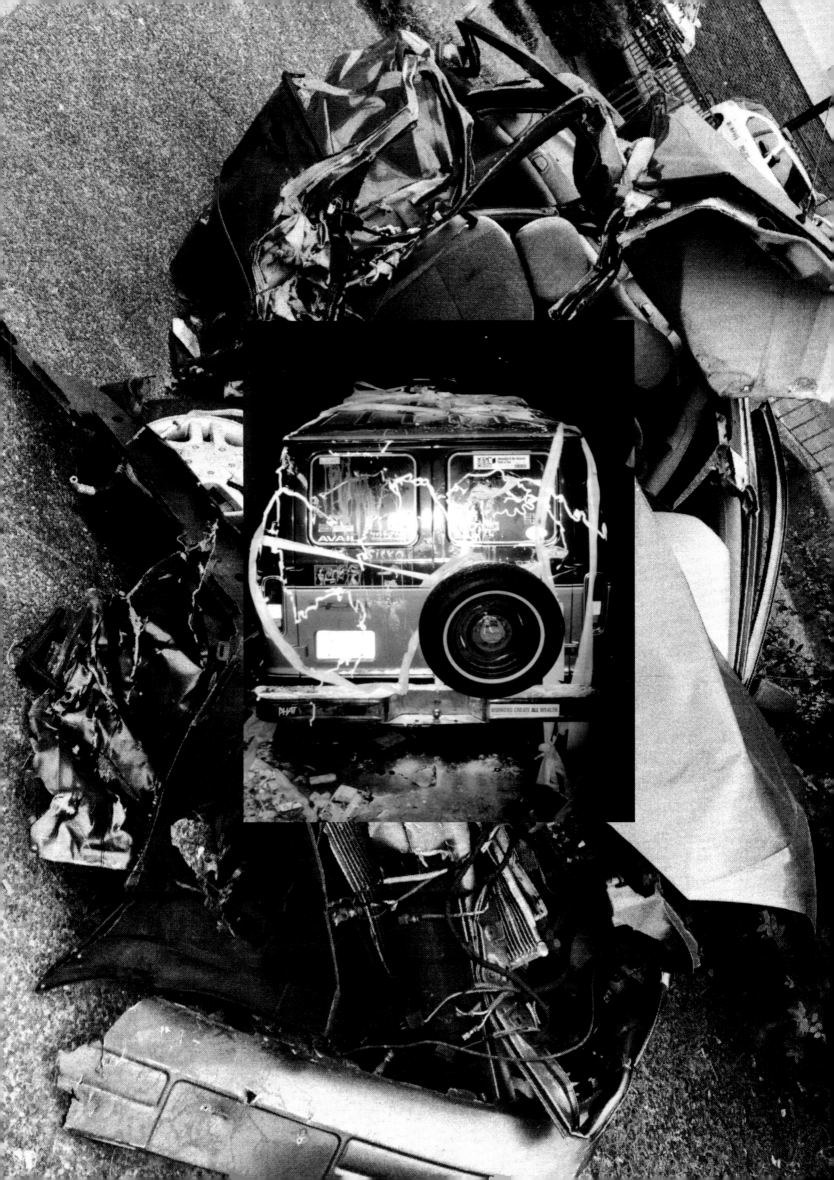

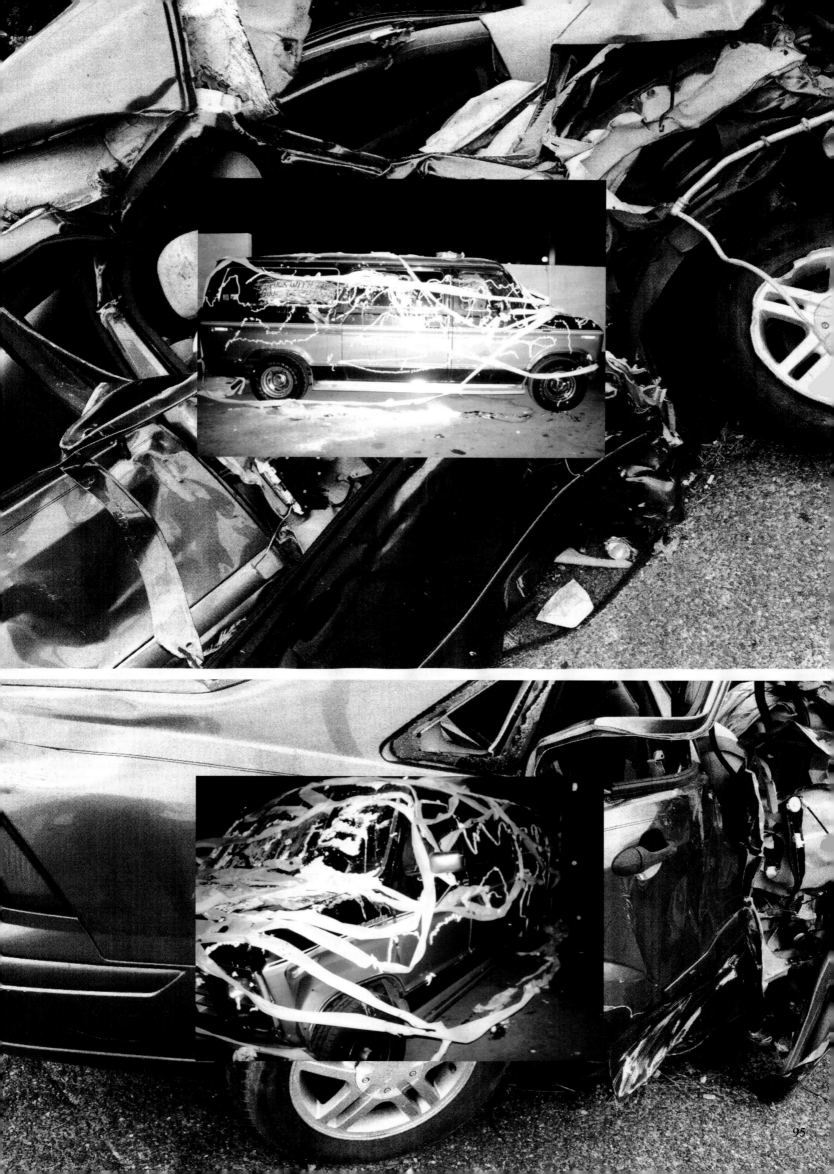

GIRL IN THE NAIL SALON

She had punched back stacked up kind of teeth, far back in her mouth with her gums all up at the front when she opened up to talk. All different shades of teeth, tan and yellow around a central black tooth. Her face was round over bones that were square, no idea of her age. What was most heavenly was her voice. The way it sounded when she spoke was like hearing an angel. Sweet and measured, celestial pauses, divinely tethered to something high above and long ago. Neither black nor tan nor yellow. Just totally transparent. The kind of voice you want to walk around with and listen to when you're blue or lost on earth.

GIRL says to the manicurist:

"I need my nails short. (pause) Be-cause I'm an artist. (long pause) Once I had them long and they scratched the paper. So I won't do th*aaaa*t again. I need 'em real short."

"We drove in from Missouri today. (pause). That's where we live. I came to Tennessee once before. I think it's the most beautiful state. Over the line and all the trees, so many trees. It's suddenly so diff-er-ent. All just beautiful. I'd always wanted to come back here. (long pause) We just got here today."

She turns to introduce the manicurist to the rest of her family who sit on a bench off behind her in the entryway. Women talking loudly, drinking cheap white wine. 6 of them. A sister, a cousin, another cousin, the aunt, the grandmother- swings back around-

"My mother, she's been everywhere. Right now she's probably gone out ta git a Coke."

"I've always been scared of big cities. But every time I get close to one, more and more I think it's nice to be close to one. (pause) I'm pretty scared but there's something nice about it not being the way I'm used to."

"It took 12 hours to drive here. It's supposed to take only 8. We had a burst out tire. A steel rod went right through our tire. It wasn't even a sharp *thing*. Real dull. Don't even know how that happened or how it coulda'. But it made the drive take 4 hours longer getting here. (pause) I'm real happy to be here now."

"I've always wanted to walk into a real crowded grocery store full of children and say "Mom!" and see how many of the children look over at me. Wouldn't that be funny?"

MANICURIST'S FACE: Confusion.

"In Missouri no one can do nails right. They are always in a rush. They won't put enough coats and you can see through them. (pause) I might have to start driving to Kansas City even tho it's probably no better. I want the dips. Thick thick dips. (pause) Or maybe I'll drive all the way here, just for dips. It's pretty far but I suppose it's worth it for dips done the right way. "

Nashville TN 1-11-19

A DIME

One dime for an idea. Anything at all. Hello Sampson, I haven't seen you around here before. For every sailor who will sail no further than in their shower. As their father. Ok, a nickel then. I'll take a nickel if that's all you got. One idea. Tell me about your days as a drag racer. Or if you've seen a flying saucer. Anything you've seen. Please say. A tea saucer then? A penny.

We used to stack the cracked up microwaves in the street and climb up to see over the fence. If we liked what we saw, we'd rearrange ourselves. We'd rearrange the cracked up microwaves into great drums. We'd pound on their backs and play to summon them over. Come over Sampson, now have a seat. We've got lettuce and a television. Not too many choices, so it can't be that hard. Wanna make it simple Sampson, you come a long way, you're fragile, you're tired. You're sweating so we'll go out and drain the lake without you. 2 hours. My penny's at the bottom. You understand Sampson. You won't miss us. Kisses.

Who's to know the address of my coat? It was dark. I was drunk but I kept you right tight there under my arm til morning. I kept you right tight there under the wheel of my car out of site of the storm, my mama an' her burglar boyfriend. I still know my priorities. The penny was obviously in my coat. I forget what you said.

Sampson say it again before I go. I'll repeat it in my head over and over as not to forget but to remember. Say it for free. I'll never ask you again. Give me a freebee cos I'm your friend.

Sampson, you're confusing me. Sampson you're being noisy! Sampson you're being unfair about this. That's my coat and you're in it AND you're not saying it right. Sampson that's something I'd say. Just cool down. Look here, now you're whispering. You're so quiet. I can't hear you. Sampson, you're silent. Oh where are you? I can't see you. It's very dark. The water's very milky. Black milky.

My penny's in there. I can't get my fingers around it. Sampson hide your feelings and help me search. Dismiss the reason and just fight. Fight to be a fighter, not a lover. Sampson, one dollar if you shoot the one in my head.

It's gross. It's warm. It's been there one week today. I'm in so much trouble, I'm willing to share. For I love you Sampson. I love when I remember to tell you. It's my very very favorite joke.

I laugh so hard. I lose control. I lose control and you see and I laugh harder and longer and longer still, for you. For this is the thing you've forgotten how to do Sampson. And to think, you say you remember everything! HA! How untrue. UNTRUE. Clever. Clever though Sampson, you do have my attention. You do have me looking for you in the blue vessels of night. I drive around and you are on my mind. A dime for that. Any idea why. – London, 2001

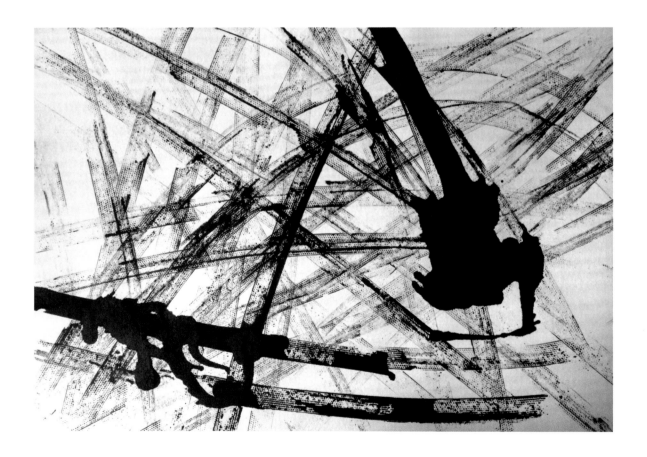

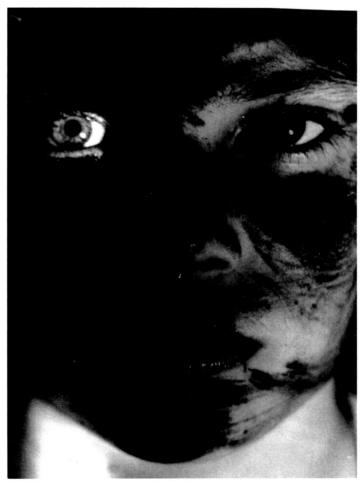

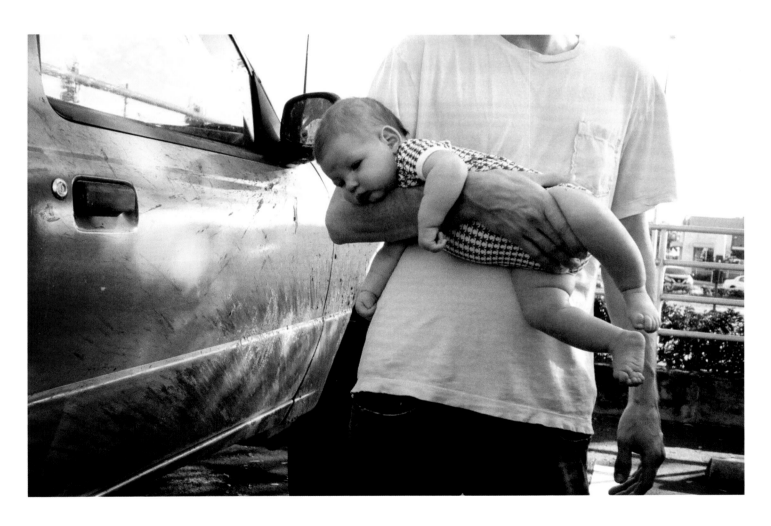

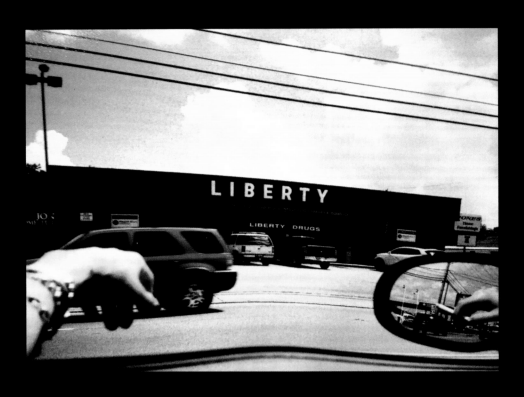

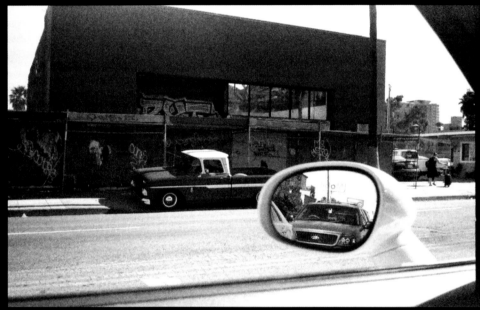

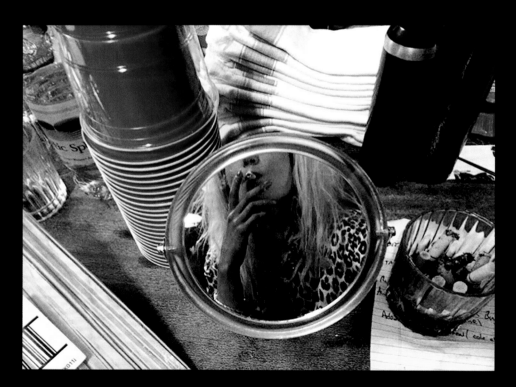

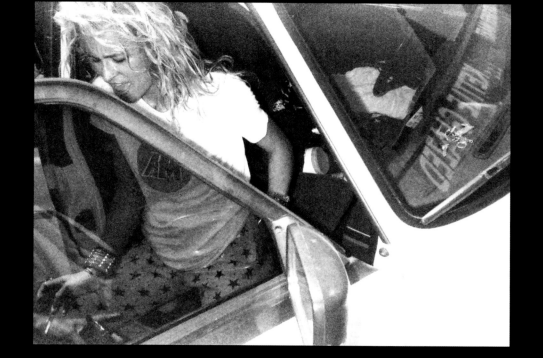

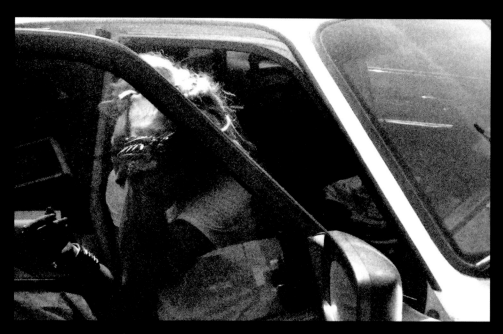

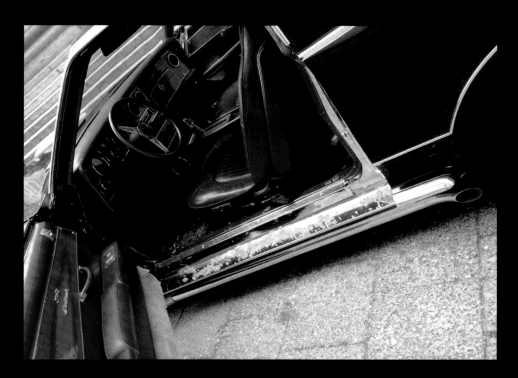

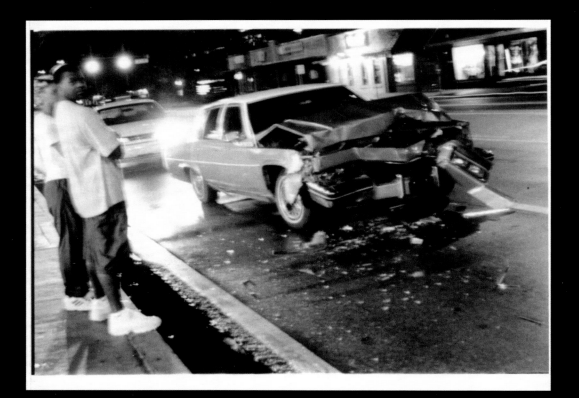

LITTLE BOTTLE

HE

The soiled hunter un-does the coat hanger thang he'd bolted down the hood with. No Good! For gods sake this truck! I HATE this truck! It makes me SO Mad! There's nothing to do. I'm dirty. I can't go back in the house. My bird whistle's full of mud. I'll get slapped. I'm hungry. I don't have nothin' out here. This is the worst day. I swear to God.

SHE

Why is he waving his arms like that??? Soiled fool. I can't believe I married. I will definitely not have children with that man. What time is it? Has it been long enough? Too long? Oh, TOO LONG, for gods sake, my hair is going to fall out. He'll divorce me. A bald wife… What's this? Was I supposed to mix this… in? I didn't even see this little one. Oh for gods sake these kits…who do they think they…

HE

I Know, I'll just find some dog in the neighborhood, skin it, she won't be able to tell. For gods sake women… they ain't even got a… Where's the…?

SHE

NOTHING'S DIFFERENT. It didn't do Anything. An hour and nothing, I can't believe this little bottle. The whole thing probably goes on in this little bottle. No, NOTHING with the big bottle. They just stick in the Big bottle to charge you more. Make you feel like you're getting bunches of bottles, Great Bargain! Where has he disappeared to?... a little afternoon neighborly thing. He can go on and have children with her.

HE

Where are all the dogs? There are always tens of dogs mutting around. Where are they? I only need ONE. This isn't too much to ask I don't think. One stupid dog. I'm starving for gods sake. And I'm burning up. I'm so damn hot. Why'd I wear all this damn hunting crap? LOOK at me. In the neighborhood. LOOK a bit of donut by the telephone box! I'm gonna eat that. I'm gonna eat it, I don't care.

SHE

her phone rings...

"Hello?"

CALLER: *"I'm telling you, I just saw your husband dressed like a commando, eating food off the ground in the telephone box. Everything OK?"*

"No. The little bottle doesn't work either."

CALLER: *"Well you have to mix the big bottle with the little bottle. Did you mix them?"*

"Yes. Of course."

CALLER: *"And it didn't work?"*

"Maybe an old batch."

CALLER: *"Could be."*

"Everything seems to be expired in that store."

CALLER: *"Your husband is crawling around on all fours."*

 "It says here, I'm supposed to mix them
 and leave it in for 35 minutes."

CALLER: *"Well you did mix?"*

 "Little bottle my ass."

-London, 2001

MIND FIELD

If it were jealousy then I'd go to much different lengths. I've had that before, I mean, it's miles man, it's miles that I'd go.

You know, there's ways of working it where it all gets chalked up as bad karma for 'em, and you can escape the blame and still be entertained by the benefits of their grief. Tellin' you sweetheart, they won't think of you.

But this isn't jealousy, it's different. It's like a wild fern. I want to cut down but I know it won't do no good but for a day or two. Then it'll be back up to strangle, rampent on the roses. Ain't much you can do but sit on your hands an' watch the time.

Are you suggesting something? Well give it to me. I'm ears, comon'. How'm I gonna let 'em know? No.

No, my blasting days have all come and gone. That's all slipped past me now. And I'm glad in a way. Don't think I'm goin' soft or nothin'. I ain't. There's just plenty of other cars to buy. Always a fresh supply. Like eggs.

I'm saying, I'm looking for a new approach. Something subtle, really good, clever. Somethin' to suck them in, a religion of sorts. Get 'em to relate to themselves, attach, dependancy, a mind field.

A sure thing. Nothing, "oh my poor vinyl seats," no I mean, I want to blow some minds. Sampson, did you hear me? You hear what I just said?

-London, 2001

I said a boom chicka boom
I said a boom chicka boom
I said a boom chicka rocka chicka rocka chicka boom
Oooooh yeah?
Oh yeah
AAAlllright?
Alright
One more time
Valley Girl Style

I said, like, a boom chicka boom
I said, like, a boom chicka boom
I said, like, a boom chicka totally chicka totally chicka boom
Oooooh yeah? Oh yeah
AAAlllright?
Alright
One more time
Outta yr' mind

I said a VROOM chicka VROOM
I said a VROOM chicka VROOM
I said a VROOM chicka rocka chicka rocka VROOM VROOM
Oooooh yeah?
Oh yeah
AAAlllright?
Alright

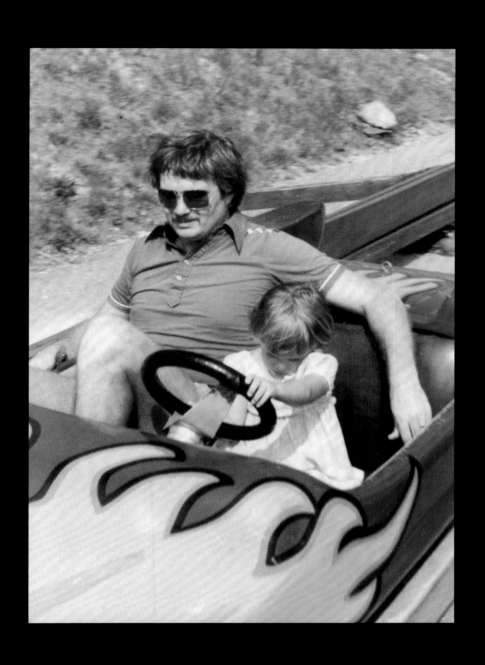

INDEX

Cover. *"You ain't no punk you punk. You wanna talk about the real junk?"* photo by Jamie Hince, outside Raoul's, New York City, 2017
Inside Cover. "Big Red" acrylic with remote control car, 2014
CAR MA. Photograph of my back by Myles Hendrik, Joshua Tree, 2017, Painted Jacket by Dana Louise Kirkpatrick, 2016
3. Text. "TALK TALK TALK"
4. "Trashed Cars VHS Dance", Vero Beach FL, stills from playback, 1998
5. "Childhood" collage on paper, 2015
6. "Pink Whip at the YMCA" Nashville, 2017
7. "De Tomaso Pantera Bull Fighter" Lakeland, FL, 2016
8. "My Parents Had a Vision" Salt Lake City, acrylic and collage, 2016
9. "Walk This Way" photograph from passenger seat, 2018, "TV KISS", 1999
10. "Tires on Set" during Canal Plus filming in Paris, 2016
11. "Guitar Cables on Polaroid", 2017, 3 "Tire Track Paintings", 2014
12. Text. "WINDOWS UP", "PINK WHIP", "LAST PACK OF HOLY SMOKES",
13. Text. "SALT LAKE CITY DRAG", "LA", "PARIS TV"
14. "HBO GO", Mixed media on newsprint, 2016
15. "Double Drive" Mixed media on board, 2016
16. Scrapbook, The Kills first tour of America, 2003
17. Scrapbook, The Kills first tour of America, 2003
18. "Wreck in Miami" polaroid, 2014
19. "Wreck in Miami" digital scene, 2014
20. (top, right to left) AutaBuy Magazine cover with Spanish newspaper cut in, 2017, "Cars in LA", 2018, "Hotel TV News" still, Dallas, TX, 2016
21. "Hot Rod Tornado", ink and collage, 2016
22. "Angelyne Leaving Denny's, Gower Gulch", LA, 2017
23. "Body Part" the Black Shark's original right front panel, 2013
24. Text. "CABLES GALORE", "THE DISTANCE", "SONIC STATES OF AMERICA"
25. Text. "MIAMI", "ADMIT IT", "ANGELYNE", "OH BLACK SHARK"
26. "Tracks for Tony", remote control car and acrylic on canvas, 2016
27. "Louisiana Hotrod" and journal entry, 2013
28. "Car Ma" magazine cover over another car magazine cover, 2018
29. "180 Point Turn" mixed media on canvas, 2018
30. "Green and Pink Spin Out" acrylic on paper, 2017, "Spin Out Portrait" on polaroid", 2017
31. "You'll Be Back", india ink on paper, 2017, "Green and Black Spin Out" on polaroid, 2017
32. "Cheese," collage on wood, gift for Nancy and Dean, 2015
33. "Triple Threat Cowboy Hero", collage on wood, gift for Steve and Page, 2015
34. Text. "HOLD ON", "LOUISIANA", "AROUND AND AROUND AND AROUND", "DEEP IN THE WOODS"
35. Text. DITW cont., "ELIMINATOR", "CHEMISTRY"
36. "Teenage Cross", (top, right to left) Friend Carrie, 1991, stuffed animal video still, 1996, Guy Picciotto, Fugazi concert, 1997, James playing bass, 1994, Dad's Corvette, 1992, Side mirror of my tour van, 1996, stuffed animal video still, 1996, Ian Mackaye's feet, Fugazi concert, 1997
37. (Top, right to left) Jay Robbins cutting tape with a razor blade, Inner Ear Studio, DC, 2000, Car at Lyman's Automotive Service Los Angeles, 2018, Empty Bottle, 1992, tire, rip, 2018
38. Scrap paper, Hedgebrook, Whidbey Island, WA, 2014, "Custom", photo, 2019
39. "Outside Wilburn Tavern the Morning After", 2018, "Low" collage, 2018.
40. "Pontiac in the Redwoods" and journal entry, 2016
41. "Over and Over, Again and Again, More and More" acrylic on canvas and remote control car, 2014
42. "76", photograph LA 2017, Me sleeping on tour, photograph by Mark Murrmann, mid 1990's
43. The Midwest in June, 1996, White Tour Vans, 1999, Light Spin Out, 1998, Mic Cable, 2016
44. Text. "LET'S START A BAND", "KEITH AND CHRISTINE WALK INTO A BAR"
45. Text. "SHE'S A TRIP", "ROAD KILL", "BOOK OF LIES: FACT #1", "ANIMALS"
46. Ad remade, from the Girls and Cars files, 2017
47. Ad remade, from the Girls and Cars files, 2017
48. "Muscle Woman Model Car", acrylic on raw canvas, 2018
49. "Sunday Style", acrylic on raw canvas, 2018
50. "Blonde Girl on Car", mixed media on paper, 2018, "Waiting for an Uber Leaning on a Cadillac" 2018
51. "Always Three When You Only Want Two", mixed media on paper, 2018, "Waiting for an Uber Leaning on a Cadillac", 2018
52. "Alice Dellal not wearing my jeans at Lyman's Automotive" 2018
53. "Audience Performance" Mixed media on canvas, 2018
54. Text. "SUNDAY STYLE", "HIGH PERFORMANCE"

55. Text. "IN BETWEEN JOBS"
56. Text. IBJ cont.
57. Text. "RETURNING THE SCREW"
58. Photograph of me and The Black Shark by David James Swanson for Junk Magazine, 2015
59. Photographs of me painting by Danny Minnick at Soho Arts Club NYC, 2019, Man polishing a Mustang at the Roosevelt Hotel, Hollywood, 2017
60. "Postcard from Los Angeles" mixed media on canvas, 2018, "Fire on the 101", 2018
61. "Psycho Highway and the American Head" mixed media on canvas, 2018
62. "Super 8" mixed media on canvas, 2018
63. Polaroids from Doing It To Death video shoot and Joshua Tree, 2016
64. Car on the highway outside of LA, 2017, Blue convertible NYC, 2016
65. "Perfectly Parked", downtown LA, 2017, "Hood" acrylic on canvas, 2018
66. "Opposites" mixed media on paper 2018
67. "Night Riders", Mexico City, acrylic on canvas, 2018
68. Text. "HIGH HORSES"
69. Text. "SUMMERTIME"
70. Text. "EASTERN STANDARDS IN THE WILD WEST"
71. Text. ESITWW cont.
72. Alice Dellal with primered Mustang Fastback, Los Angeles, 2018
73. "Charlie Sexton playing guitar in the backseat", and "A True Texas Ride" behind the Granada Theatre, Dallas TX, 2017
74-75. Jamie Hince and I with a Stutz Blackhawk in Berlin, 2016, "Elvis's Wheels", Graceland, 2018
76-77. "Oldsmobuick Dead Body", (longest car I've ever seen), LA 2018
78. (From right to left, top to bottom) photo of me on my rental at the Chateau Marmont by Felisha Tolentino for Nylon Magazine, 2016, Still from Canal Plus, 2017, Me and The White Shark, LA, by Myles Hendrik 2017, photo taken from The New York Times of a crash, 2018, Photo of me on The Black Shark Nashville by Wrenne Evans 2018, Vanishing Point Still from the movie, 1971, painting "Big Red" photo by David James Swanson, 2014, fucked car from the internet, 2016, The White Shark on FF-1051 Gallery CCTV, 2018, The Kills "Baby Says" record sleeve, 2011, guitar cables at Electric Lady NYC, 2016
79. Instagram post, June 12, Munich, GY, 2017
80. "Daughter of the American Used Car Dealer", mixed media on canvas, 2014
81. "Dream & Drive, neon sign commissioned by Kenneth Cappello for his photography show, Dream and Drive- photographs of The Kills by Kenneth Cappello, 2012
82. Heritage Classics Motorcar Company's cherry red 442, Beverly Hills, 2018
83. Reshot magazine photo, 2017, Hotel Bed, SF, 2015, crashed car somewhere in America, 2015
84. Text. "THE ELECTRIC SADS"
85. Text. TES, cont.
86-89. Vanishing Point film script, 1971 written by Guillermo Cabrera Infante, still from movie poster, 1971
90-91. Woody Creek Tavern, Aspen Colorado, 2018, detail stills of car auction on tv, 2018, Matthew Mosshart and Becca Noland, 1992
92. Road shot Palm Springs, 2018, Flame Van, Austin Speed Shop, Austin TX, 2018
93. 2x Wheels, Porsche Rennsport, Monterey, CA 2018, Front End, Wilburn Tavern, Nashville, 2018, 2x kaleidoscope photos, 2015, self portrait, Hedgebrook WA, 2018
94-95. Car outside police station in Memphis, TN 2018, "Discount's Tour Van", parking lot somewhere in America, 1996.
96. Text. "GIRL IN THE NAIL SALON"
97. Text. "A DIME"
98. Guitar cable and speaker polaroids, Electric Lady Studios, NYC 2015, "Machine Gun and Electric Guitar" ink on paper, tire track painting, 2014
99. "Tire in Space" mixed media, 2013, "Matthew's Eye", photograph 1992
100. "Succulent" LA, 2017, "Mud Truck", Florida, 2016
101. "Someone's Green Dream" Vero Beach, FL, 2016, "Goldy with Dad and Dirt Truck", Florida 2016
102. "Side Mirrors", 2016
103. "Open Doors", 2018, 2016
104. "Out the Windshield", LA, 2017, "Wreck on Tour", Atlanta, 1998
105. "Get Hooked", collage, 1999
106. Text. "LITTLE BOTTLE"
107. Text. LB cont., "MIND FIELD"
108. Text. "BOOM CHICKA BOOM"
109. "Dad and I on a Ride", photo by Vivian Mosshart, 1983
110-111. INDEX

Thank you: Jamie Hince, Myles Hendrik, Holly Purcell, Camila Dixon, the FF-1051
Gallery, Angelyne, Hedgebrook, Mark Murrmann, Stacy Fass, The Peterson Museum,
Richard Prince, Barry Newman, Alice Dellal, David James Swanson, Danny Minnick,
Danny Zovatto, Tim Cadiente, Mariela Martínez S, Andrés Medina, Cesar Rosas,
Panteón MX, Elvis, Ethan Hawke, Charlie Sexton, Lyman's Autobody Shop, Felisha
Tolentino, Canal Plus, Wrenne Evans, Electric Lady Studios, Heritage Classics
Motorcar Company, Dodge, Circuit of The Americas, Dana Louise Kirkpatrick, Helen
and Tony, Vanishing Point, Kenneth Cappello, Austin Speed Shop, Mark, Vivian,
Matthew and Goldy Mosshart.